MUCH LOVED

PHOTOGRAPHS BY MARK NIXON

ABRAMS IMAGE NEW YORK

Dedication

I would like to dedicate this book to my family, for their love and patience.
In order of appearance: my mother, Pauline; my sisters, Mandy and Kathy;
my brother, Adam; my wife, Lorraine; and my children, Pearl and Calum.

Also to my best friend and fellow photographer, Mark Griffin, whose
support and encouragement over the years have made what can be at times
a lonely occupation full of fun and mischief.

And to all those who brought or sent me their precious teds to be
photographed and who shared their personal stories and memories with
such openness and honesty.

Editor: David Cashion
Designer: Deb Wood
Production Manager: Anet Sirna-Bruder

Library of Congress Control Number: 2013936015
ISBN: 978-1-4197-1012-4
Copyright © 2013 by Mark Nixon

Printed in the U.S.A.
10 9 8

Abrams books are available at special discounts when purchased in quantity for premiums and promotions as
well as fundraising or educational use. Special editions can also be created to specification. For details, contact
specialsales@abramsbooks.com or the address below.

ABRAMS The Art of Books
115 West 18th Street, New York, NY 10011
abramsbooks.com

WHO KNEW?

Much Loved started as a very simple idea: to photograph some "loved to bits" teddy bears for an exhibition in my studio, which happily has a gallery space.

I got the idea from watching my son, Calum. I was struck by how attached he was to his Peter Rabbit, the way he squeezed it with delight when he was excited, the way he buried his nose in it while sucking his thumb, and how he just had to sleep with Peter every night. I vaguely remembered having similar childhood feelings about my own Panda.

The photographer I admire the most is Irving Penn. His portrait work, from the 1940s and 1950s especially, made me want to become a photographer. With his still-life work, I loved the alchemy of his Street Material series, how he could take pieces of trash and cigarette butts off the street, photograph them, and turn them into works of art. The idea of making an everyday object, something so familiar that it's invisible, become visible again appealed to me.

So, I put the call out for people to bring in their much-loved teddies—the more loved, unwashed, and falling apart the better—to be photographed. I expected it to be mostly children, but it soon became apparent that the idea appealed very much to adults, and that many of them were still very attached to their teddies. It was as though they had been keeping a long-held secret and could finally tell someone what their teddies really meant to them.

Their strength of feeling took me by surprise. While waiting, they would tell some usually funny story about their teddy (how they had nearly lost it at some stage was a common theme), or would speak emotionally about

what it meant to them. So the stories and memories became integral to the photographs, adding significance to them and bringing them to life.

One of these people, who had studied psychology, told me about the "transitional object" and later e-mailed me a link to some papers written on the subject. From what I understand, a transitional object is a teddy or a soft toy that is used as a kind of stepping stone in the separation of the baby from the mother. It is the first object apart from the mother that the baby becomes attached to, their first possession, and whether a child has something like this or not may affect them in later life. The adults who came to me with their teddies would certainly attest to the positive benefits of having had a transitional object.

When I sat down to write the press release for the *Much Loved* exhibition, I couldn't quite put into words the feelings I had about it, these vague childhood memories and emotions. But before I knew it, I had written a poem, which came as quite a surprise to me, since I had never written poetry, nor had I read any since I was in school.

The exhibition launch went very well, and once it had opened I uploaded the images from it to my website, along with their related stories, and that's when the real fun began.

Within a month, the website had received more than 1.5 million hits; within three months, over 4.5 million. It was featured on news feeds and blogs all over the world, from China to Peru, Iceland to Argentina, America to Russia, and all over Europe. Then some magazines published features on it, and finally, just as I was starting to think it might make a good book, a few publishers got in touch with me. It seemed like almost every day there was something new and exciting happening with it.

When David Cashion from Abrams first e-mailed me, I knew that he would be the one to publish this book. All he said was, "Dear Mark, Everyone here at Abrams Books has fallen in love with your series, *Much Loved.* Would you consider turning this project into a book?"

And so, here it is.

—Mark Nixon

Much Loved

When everything was unknown, they were there.

Where anything could happen, they were there.

These repositories of hugs, of fears, of hopes, of tears, of snots and smears.

Alone at night, they were the comforters, when monsters lurked in darkened
 corners, when raised voices muffled through floors and walls.

These silent witnesses, these constant companions, defenders of innocence.

Their touch, yes, but their smell, that instantly calming, all embalming musk,
 unique to each, soothing and smoothing the journey from consciousness to
 un, from purity to im, from infancy to adult-terre.

Sworn to secrecy, unconditionally there, unjudgmentally fair and almost
 always a bear.

<div align="right">—MN</div>

Peter Rabbit

AGE: 10

HEIGHT: 16"

BELONGS TO: CALUM NIXON

Peter Rabbit was the inspiration for this project.

Calum's ninety-nine-year-old great-grandmother, Eva, bought Peter for Calum when he was born and Calum has slept with him every night ever since.

Scores of teddies and soft toys now reside in black sacks in the attic, but Great-Granny knew what she was doing: Peter stuck.

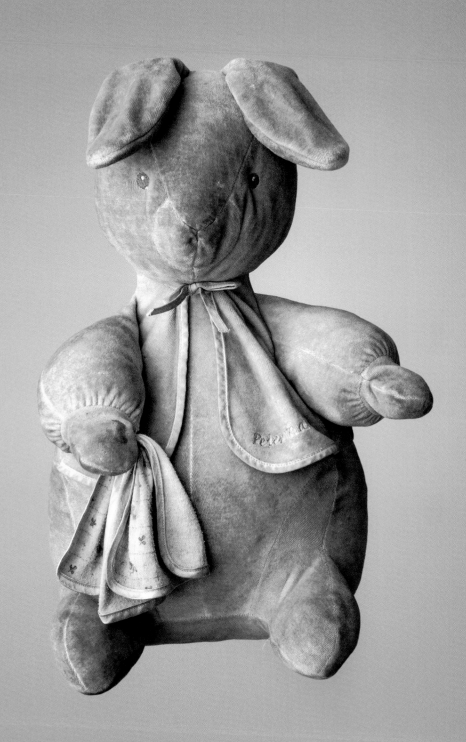

Greg's Bear

AGE: UNKNOWN

HEIGHT: 4"

BELONGS TO: BONO AND ALI HEWSON

Ali Hewson wrote: This little bear is a
memory of one of the most incredible men
in my life. Greg Carroll became a great
friend to me and Bono in the early 1980s.
In 1986 he died at the age of twenty-six in a
motor accident in Dublin, and he left a giant
hole in our lives. Greg was a Māori, and at
his *tangi*, the traditional Maoři funeral rite, a
mate of his handed us this one-eared teddy
bear. It was Greg's, and it has been with us
ever since . . . a fragment of Greg's reality,
gone but never forgotten.

U2's "One Tree Hill" was written for
Greg and all the great men and women
whose river reaches the sea too quickly.
Greg's teddy smiles when his good ear
hears it played.

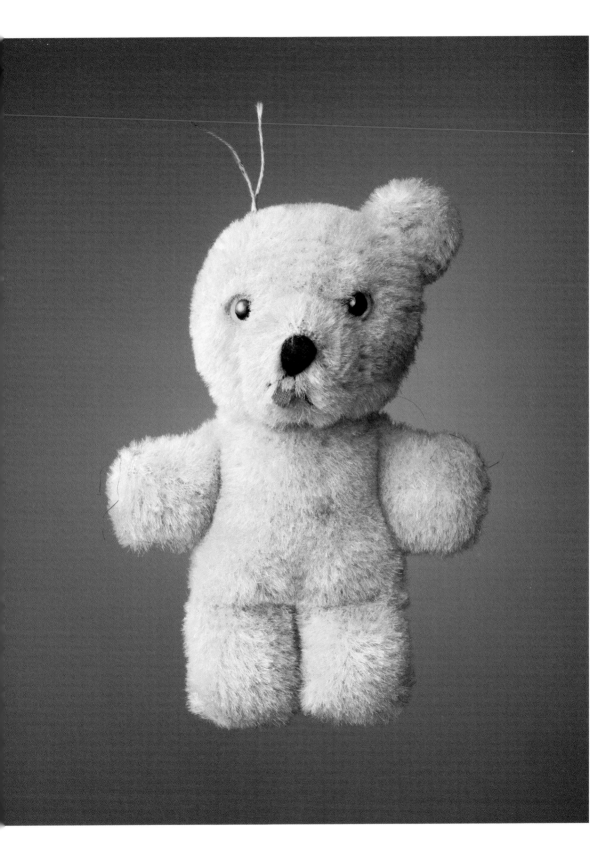

Pink Teddy

AGE: 24

HEIGHT: 13"

BELONGS TO: AISLING HURLEY

Pink Teddy was born on Christmas Day 1988, when I was six months old. Back then, he was bright pink with a red waistcoat, and we were instantly inseparable. We have been apart for only a few nights since. He even came to college with me, but during this time the greatest tragedy befell Pink Teddy. The week before Christmas break, there was a huge house party. It was an epic night, but the following morning when I got up to survey the damage to the place, I saw something truly awful . . . Pink Teddy had been ripped limb from limb. My housemates woke up fairly quickly when they heard me wailing, and they sprang into action. Someone got me a cup of tea and a jumper, and then someone carried out the delicate operation of retrieving Pink Teddy and wrapping him up in a blanket. I was so distraught that I rang my mam and bawled down the phone. She reassured me that my great-aunt Rosaleen could fix him and said she would come and collect us. My great-aunt managed to patch up Pink Ted and she even gave him some more stuffing, because he had been getting rather skinny. That was nearly four years ago and he is still looking good, although now his left arm is sort of hanging on by a few threads.

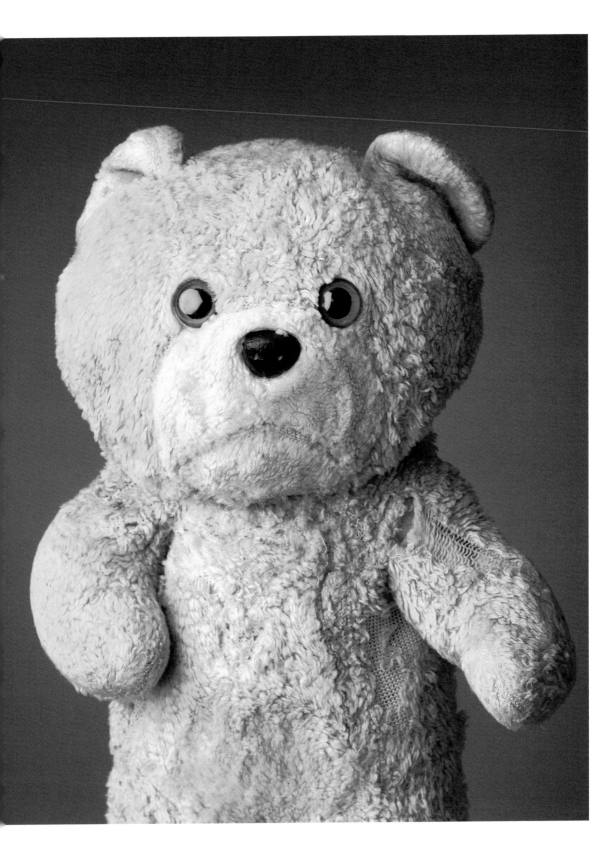

Pierre

AGE: 9

HEIGHT: 12"

BELONGS TO: CHARLOTTE MCDONNELL

Pierre came from Paris. He originally belonged to Lara (Charlotte's sister), who lent him to Charlotte when she was born and never got him back. He goes everywhere with Charlotte except school.

One day Pierre got lost in Kildare Village, and Mum Hazel searched everywhere for him in a state of some distress. Finally she found him at the Ralph Lauren wrapping station and broke down crying, "You have Pierre!!" startling the staff.

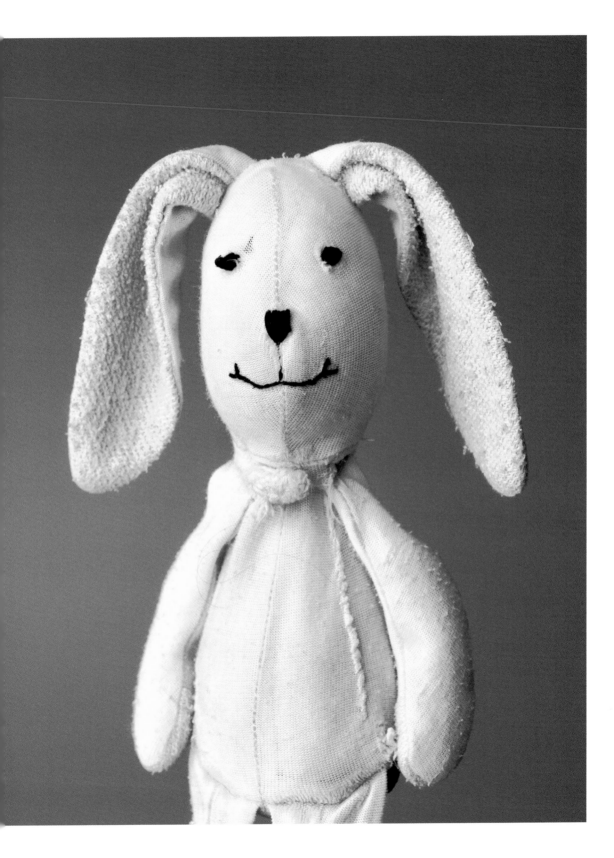

Teddy Moore

AGE: 43

HEIGHT: 14"

BELONGS TO: DARAGH O'SHEA

Daragh's father was given a pound from his parents for his birthday and he bought Teddy Moore for her. Under his hat and clothes, Teddy Moore is held together with nylons.

Although he looks like he was in a fire, in Daragh's own words, she kissed the fur off him.

He lives in the locker beside her bed; she doesn't like him sleeping in the bed in case she smothers him.

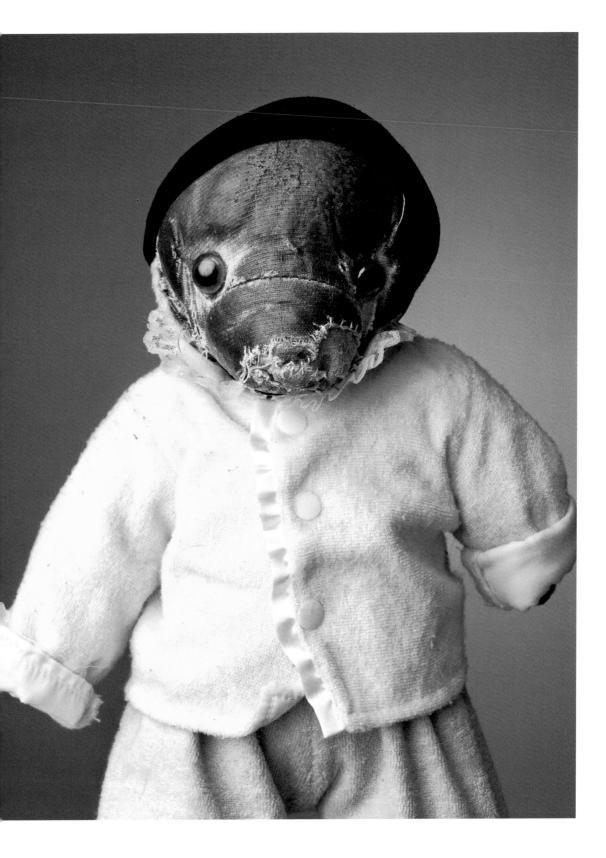

Teddy

AGE: 42

HEIGHT: 36"

BELONGS TO: DEREK WARD

Teddy was given to Derek by his mam
when he was born. Teddy now wears an
outfit Derek wore when he was a child.

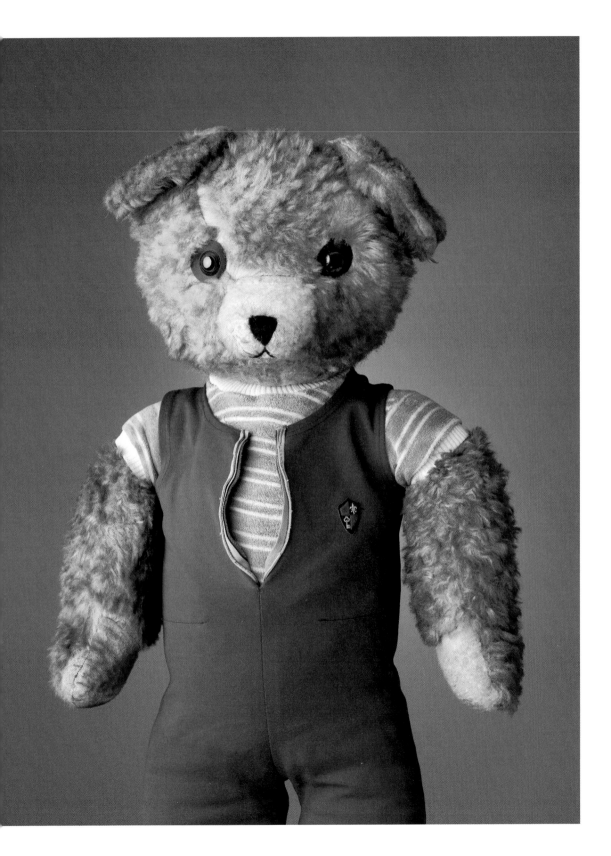

Ted

AGE: 49

HEIGHT: 15"

BELONGS TO: FRANCES CURTIN

Ted was a present from Frances's father's sister. Frances never saw her aunt again after the day she received Ted and only heard of her once after that: She turned up drunk when her father was dying and was thrown out of the house.

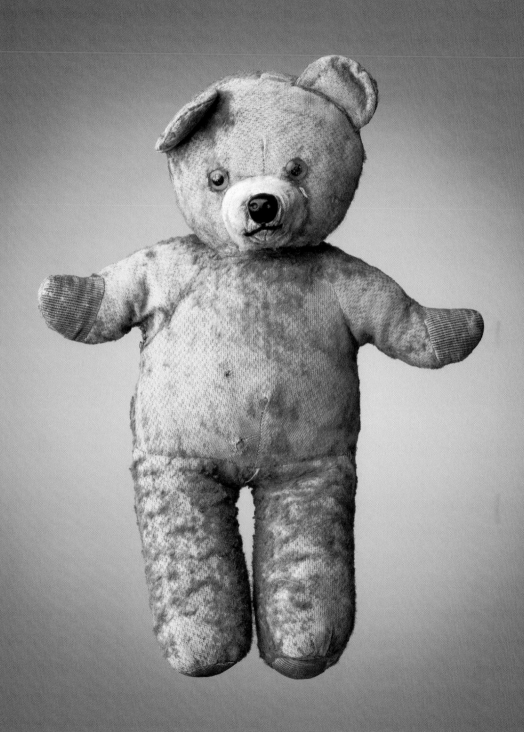

Ted Ted

AGE: 5

HEIGHT: 6"

BELONGS TO: FREDDIE BRACKEN

Ted Ted has lost both his feet as well as his attached "blankie" due to Freddie's rough play and chewing.

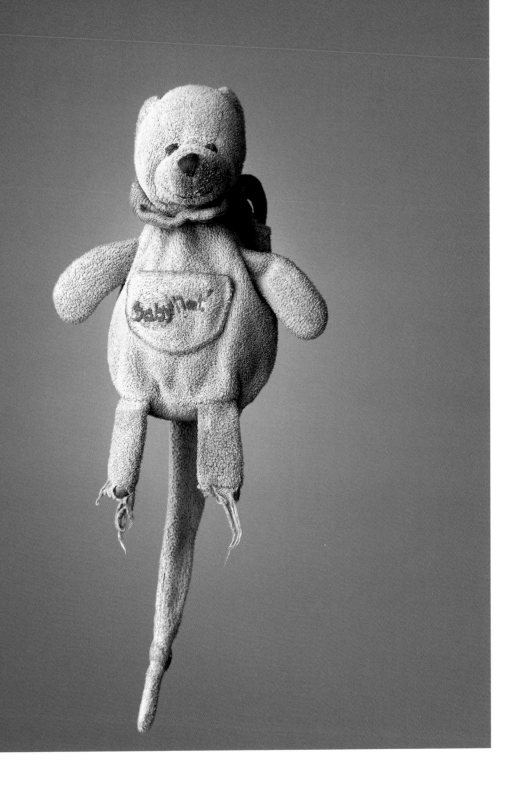

One Eyed Ted / Aloysius

AGE: 55+

HEIGHT: 13"

BELONGS TO: GERRY RYAN/BABETTE RYAN

Gerry and his brother Mano both owned this bear as children. Gerry took to carrying him around as an adult after watching *Brideshead Revisited* and renamed him Aloysius. He often spoke of him on the radio show he hosted for twenty-two years. There is still a trace of lipstick visible that Gerry's mother, Maureen, applied at one point.

Since Gerry's sudden passing in 2010, One Eyed Ted is being cared for by Gerry's daughter Babette.

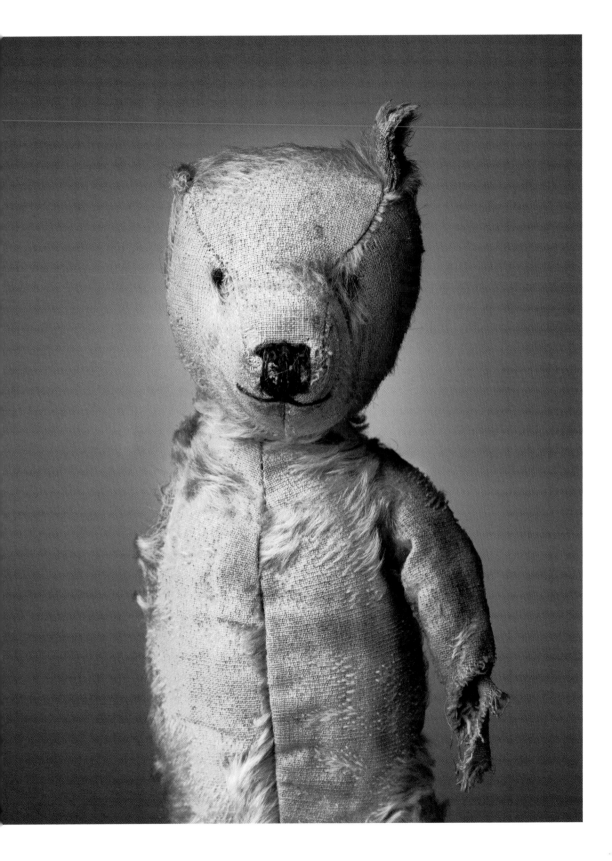

Bed Ted

AGE: 22

HEIGHT: 8½"

BELONGS TO: FEABHA HOARE

Bed Ted started his life out in Chester, England. He was given to me for my first Christmas, twenty-two years ago, by a friend of my mother's. Since then, he has slept in my bed every night.

In his earlier years he accompanied me on most daily outings.

I remember him going missing once during my teens. After a few weeks of searching the house, I finally (and reluctantly) accepted that he might be gone for good. Obviously having a great zeal for fashion, he later reappeared in my wardrobe among some jumpers.

He has worn many different T-shirts over the years in various colors and patterns—my mother having made all of them from interesting odd socks.

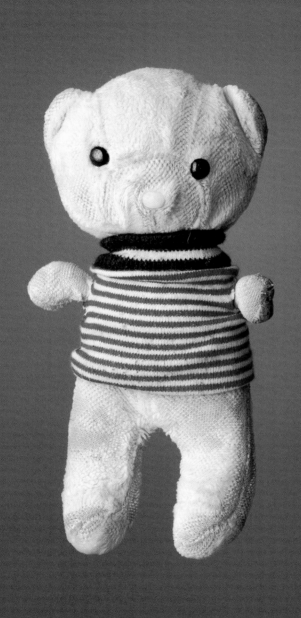

Ted

AGE: 35

HEIGHT: 13"

BELONGS TO: ANNE MARIE LENTS

Ted lost his eye defending me from a terrier at day care. (That's the short version of the story.) He also keeps all my secrets in the compartment created by his flattened nose.

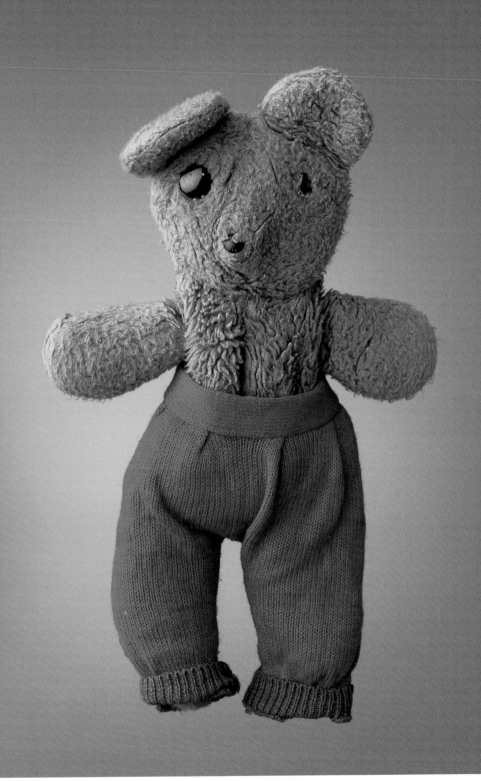

Flopsie

AGE: 6

HEIGHT: 14"

BELONGS TO: LUA SPENCER

Lua's aunt, who's a nurse, put a bandage on Flopsie's leg to stop the stuffing from coming out.

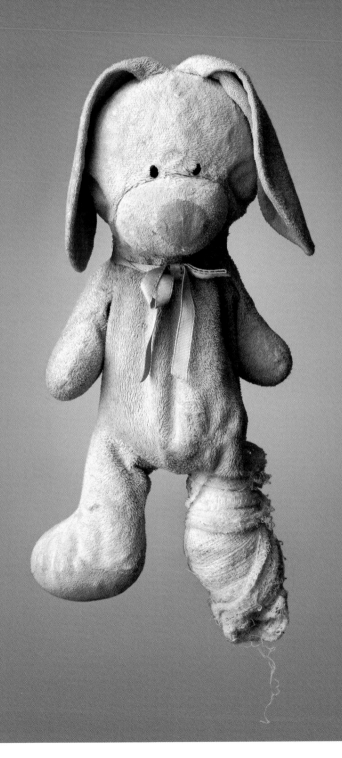

Brownie

AGE: 30

HEIGHT: 12"

BELONGS TO: JENNY SLATTERY

This is Brownie, the world traveler and party animal who is much misunderstood by all except his best friend, Jenny.

Brownie has seen the world from Maui to Montauk, Bangkok to Ballsbridge. He has traveled on trains and planes and has even been known to take the bus by himself. During his early years he suffered much adversity at the hands of his evil stepsisters and the family cat. But he overcame all to make his escape to the big city at the tender age of seventeen years. Unfortunately this wasn't the panacea he had hoped for. During his college years, he was ostracized by his fellow students, who jeered at him for his unusual appearance and distinctive aroma.

It is true that Brownie never washes, but therein lie his special powers. To those most important to him, his subtle, musty bouquet has the power to comfort and reassure. His battered and worn fur is soft and calming to the touch. Now at thirty years of age, Brownie shows no sign of settling down. He lives an alternative lifestyle, sharing a bed with Jenny and her husband in Milltown, and is old and wise enough not to care what anybody thinks of him anymore!

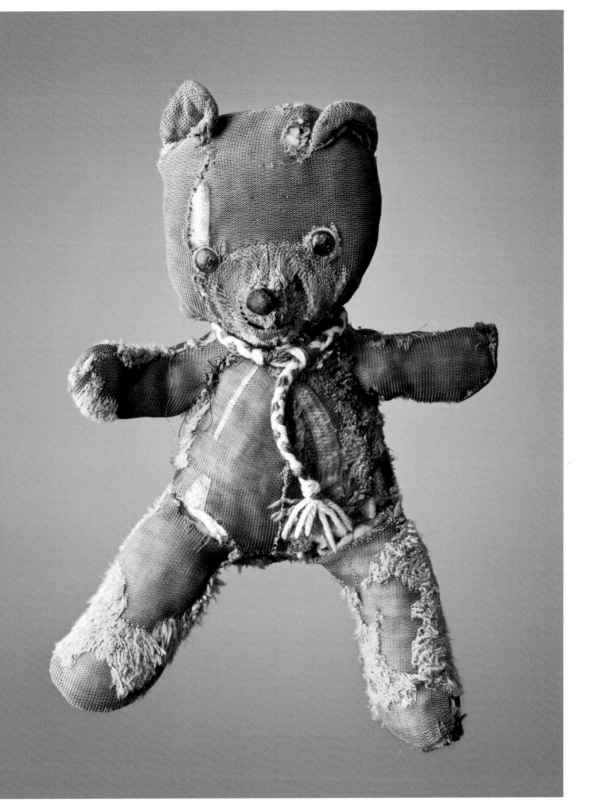

Ted

AGE: 24

HEIGHT: 9"

BELONGS TO: HELEN LYONS

Ted was given to my mum just before I was born. He started out as a bright pink teddy with a blue star on his chest. Through the years he has lost eyes, limbs, and stuffing; however, Ted is still very loved and cherished.

When I was young my granny would make constant repairs to his neck and arms. She gave me a small angel pin to attach to him for my Communion. That pin has stayed on his chest ever since.

I had a habit of rubbing his eyes with my finger for comfort; they are made of glass and always felt cold. His nose is disappearing into his face as I had a particular way of holding him, which also means the fur is missing in distinct patches on the back of his head.

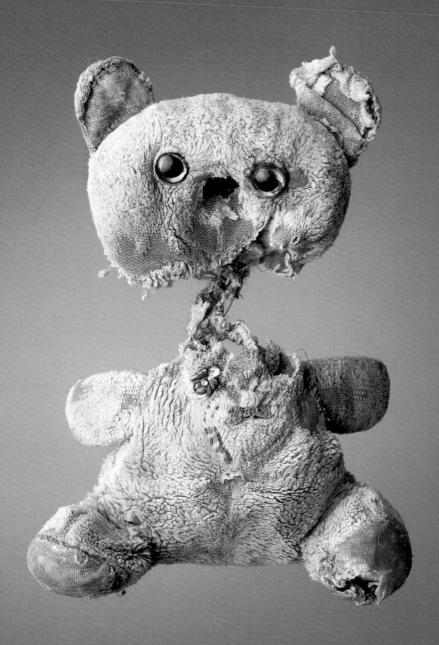

Joey

AGE: 44

HEIGHT: 11"

BELONGS TO: JEAN CHERWAIKO

I received Joey from my granny the day I was born and have loved him unconditionally ever since. I think in his early days he squeaked, but now he just holds the hard remnants of a noisemaker in his saggy belly. His straw insides have diminished over the years. I distinctly remember a fight with my brother Brian, when he pulled the insides out of poor Joey.

He has had many operations over the years, including new red-button eyes and pieces of an old towel sewn around his hands to hold the stuffing inside. His face is now filled with nylons and he wears a lovely sweater that was made by my sister Antoinette.

He has traveled the world with and without me, somehow ending up in New Zealand with an ex-boyfriend of mine, only to be mailed back to me in Canada, where I now live.

Joey slept with me until I was married and now has his own little rocking chair in my room.

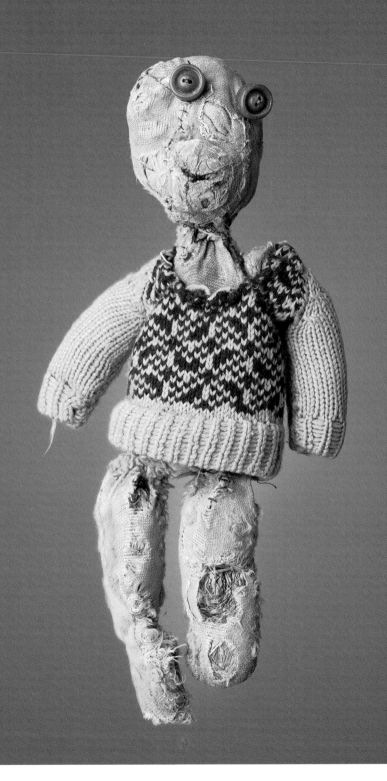

Billy

AGE: 102

HEIGHT: 14"

BELONGS TO: JUNE MAYBURY

Billy belonged to June's uncle, Alan Sinclair,
who received him when he was four years
old. At twenty, Alan moved to England for
work and left Billy behind. Billy was then
passed on to June and her brother Darrell.
He was kept in the ottoman and taken out
at random intervals to be played with briefly
and then returned. He now lives in June's
china cabinet with a doll called Beryl.

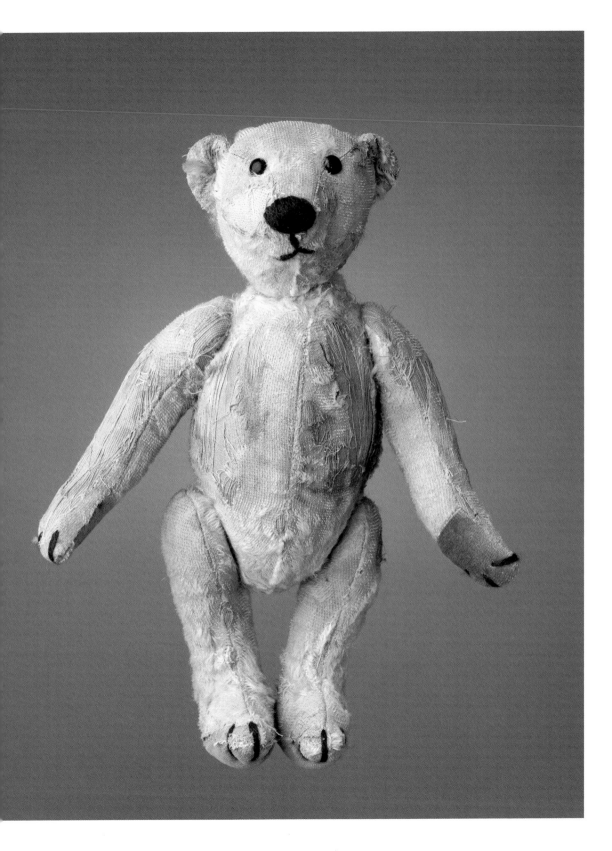

Teddy

AGE: 78

HEIGHT: 19"

BELONGS TO: KEN NIXON AND CALUM NIXON

This teddy was given to my father, Ken, on his first birthday in 1935. His mother, Eva, my granny, made the clothes for Teddy. My father, in his cot, used to love standing on Teddy's chest to make him growl. When he was seven, he gave Teddy to his little sister Nola as a present when she was born.

Nola is the family historian and she has kept a lot of family papers, photos, and bits and pieces. She gave Teddy to my son, Calum, a couple of years ago after my father died. It was the first time I had seen or heard anything about him.

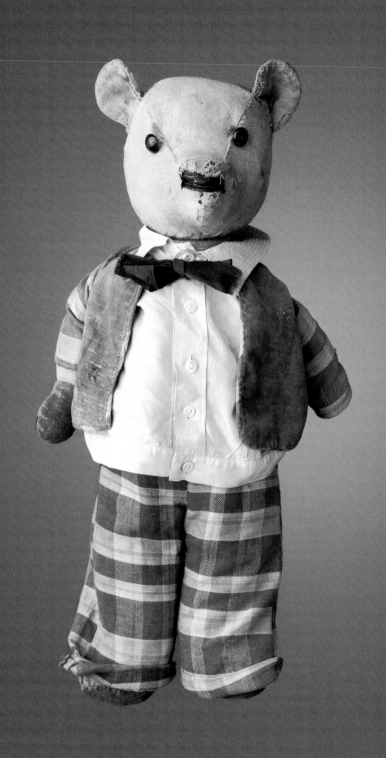

Peter

AGE: MID-50s

HEIGHT: 24"

BELONGS TO: MAEBH O'CONNOR

Maebh brought Peter in to see the *Much Loved* exhibition.

Maebh's only attempt at knitting was to make Peter's playsuit. It is full of imperfections, as you can see, but that only makes it more unique.

Up until the exhibition, Peter was languishing in the spare room. Since coming in for his photo shoot, he is now a celebrity in the house and has pride of place in Maebh's bedroom.

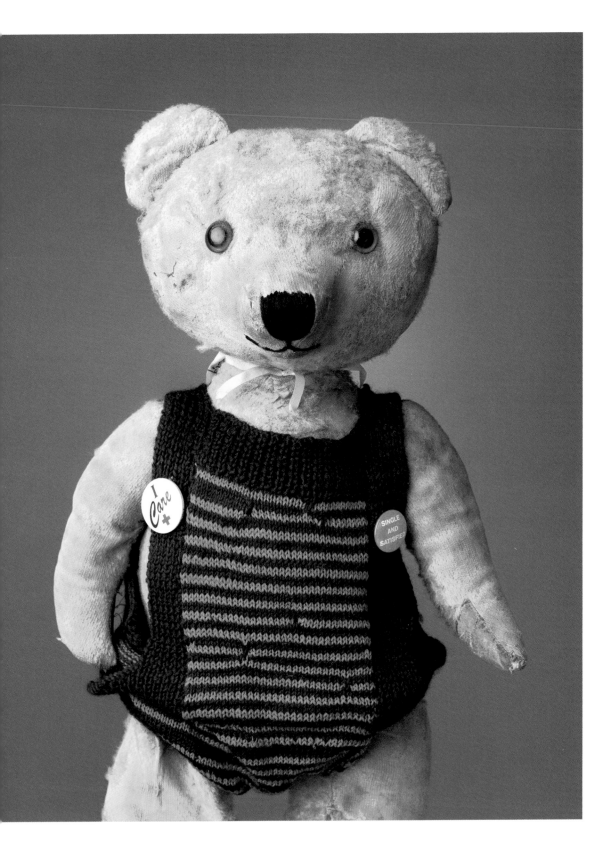

Ear Open

AGE: 32

HEIGHT: 10"

BELONGS TO: MAEVE WHELAN

Ear Open was given to me in 1981 by my grandparents for my first Christmas, just before we moved to Luxembourg (which in the 1980s felt like the other side of the world).

When I was two years old, I named him Ear Open. I used to carry him around by his ears (which have holes in them).

He has seen me through every stage of my life and is a very understanding, resilient creature.

He started losing his fur roughly ten years ago. I brought him to the teddy bear hospital (see the Melissa Nolan entry, p. 62) to see about getting him some new fur, but I was told his teddy leprosy was incurable and he would need a totally new fur coat, which could never match his original one.
I decided against him having this procedure, so now his once-bright, glorious yellow fur is hanging off, but I love him all the more for it.

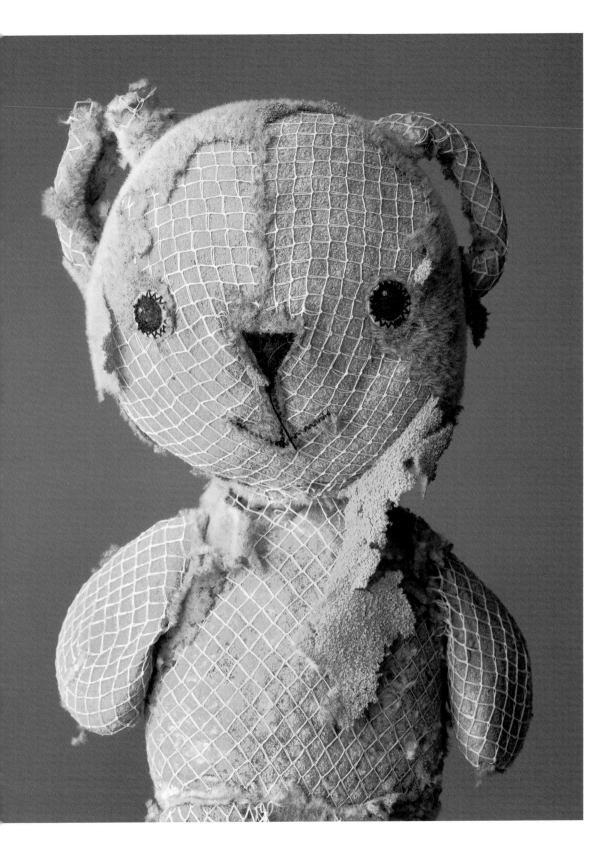

Teddy

AGE: 16

HEIGHT: 8"

BELONGS TO: LUKE FOLEY

Teddy was put in the crib one hour after Luke was born. He has been lost a few times since then; once on a family holiday in Tunisia, but after a major appeal, he was found ten miles away!

Another time, after searching everywhere, we thought we had lost Teddy for good, so we called the Steiff factory in Germany to see if they had a replacement, but as Teddy was a limited edition, they didn't. Teddy finally showed up sometime later in a chess game box.

Even though Luke is sixteen now and won't admit it, if he comes across Teddy, the first thing he does is pick him up and smell him.

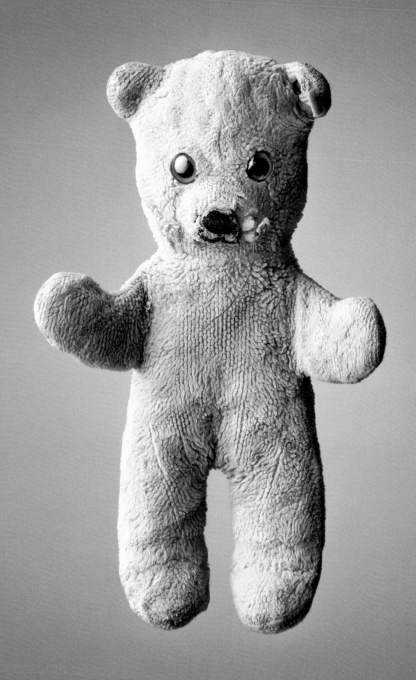

Panda

AGE: 50

HEIGHT: 16"

BELONGS TO: MARK NIXON

I think I only ever called him Panda. I remember clearly snuggling up with him in bed as a child, which is probably why watching my son, Calum, with his teddy spurred me on to starting this project.

As I grew up and my interests focused elsewhere (girls and music mostly), Panda spent many years on top of the wardrobe in the spare room of my mother's house. From there, he migrated to a cardboard box in her attic and finally the box came down with the ultimatum, "Take it with you or it's going in the bin." So he joined the scores of other soft toys belonging to my children and landed in a trunk in the spare room. I have just pulled Panda out to photograph him for this project and he smells a bit musty, but I have decided to keep him beside my computer in my studio while I work.

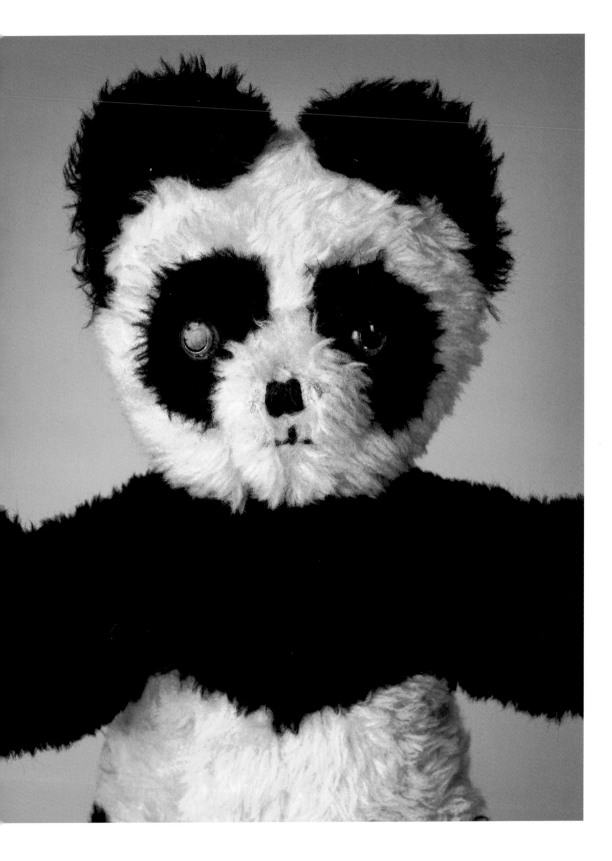

Big Ted

AGE: 43

HEIGHT: 25"

BELONGS TO: MAIREAD HARRINGTON

Big Ted used to belong to Mairead's brother David. He was named Big Ted because he was bigger than Mairead at the time.

David held a race in the back garden between Mairead and their sister Elizabeth to see who would win Big Ted for a week. Mairead won, but she never gave him back!

He travels to Donegal with her in the car, sitting on a cushion on the hand brake.

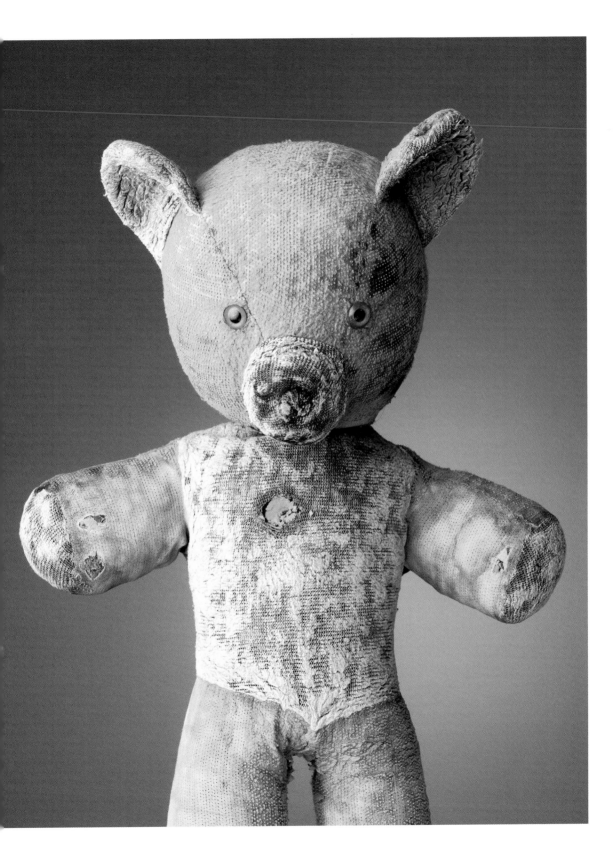

Gerry the Giraffe

AGE: 10

HEIGHT: 23"

BELONGS TO: SOPHIE FARRELL

Gerry was a christening gift for Sophie.
He plays music when you pull his string.
 Sophie's teacher knitted a jumper for
Gerry to stop his stuffing from falling out.

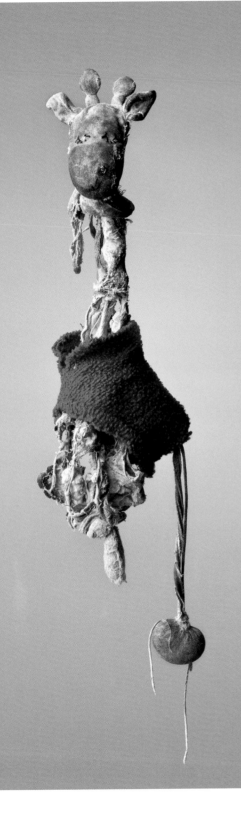

Teddy

AGE: 51

HEIGHT: 46"

BELONGS TO: ISOBEL SMITH

Mark Nixon wrote: Isobel was a friend of mine who sadly passed away a few years ago. Her brother, whom I didn't know at the time, heard me talking about the *Much Loved* project on a radio show and brought in Isobel's teddy to be photographed. It was only during the shoot that I realized whose teddy it was.

Stephen, Isobel's brother, wrote: Teddy was bought at the Düsseldorf airport in 1962 by our father. This was the first of many flights Teddy would take with his companion, Isobel. They traveled the world and enjoyed many glamorous times together. However, it is not known how his leg fell off! Due to chronic overcrowding and recessionary cutbacks, Teddy is still waiting for a bed in the teddy bear clinic. He is now cared for by Isobel's nieces Robin and Lauren.

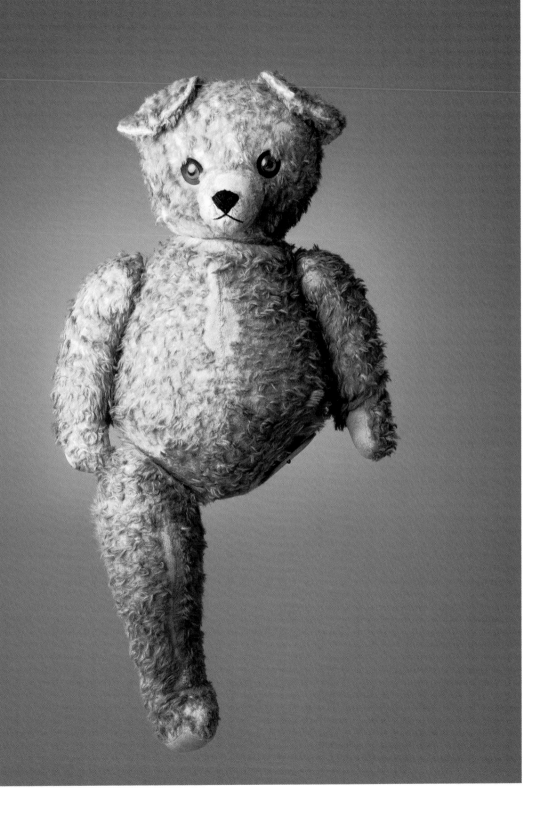

Ted

AGE: 21

HEIGHT: 18"

BELONGS TO: MELANIE MORRIS

A snowy white bear when he came to stay in 1992, Ted, as far as we know, has never seen the inside of a washing machine and thus could be described as "ripe" by anyone who comes near his personal space.

Much loved by his owner (and only by her), we're not sure if Ted has mild Tourette's or is simply a grumpy old sod, but he's never happy with his lot, and has a tendency to use inappropriate, foul language. He's furious that some Hollywood screenwriters stole his persona for the recent movie (which they even named after him).

Ted is beginning to show his age; he'd a narrow escape nearly losing an eye recently, and is beginning to get a bit saggy and threadbare. Hence, he can be frequently found wandering around Penneys's children's wear department, looking for suitable attire. He has a particular penchant for Babygros, tutus, and Ugg-style boots, which he tries to finance by selling gold (not his) for cash.

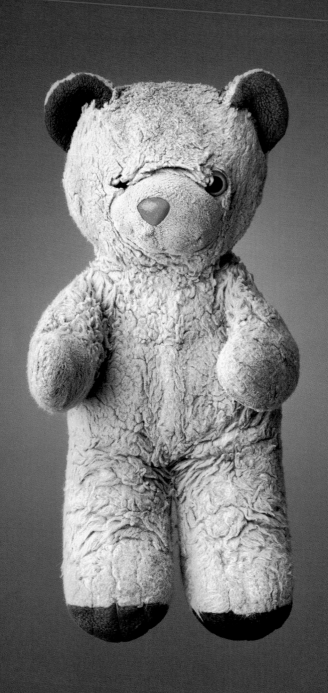

Teddy

AGE: 63

HEIGHT: 16"

BELONGS TO: MARGARET CLONAN

Margaret's dad bought Teddy for her when she was a baby. Teddy was her constant companion and she slept with him until she was twenty-one, when she got married. (She hid him in her suitcase on her honeymoon.)

Teddy now sits on a shelf with her hubby's teddy dog. She says Teddy has gone everywhere with her and will be buried with her, so they can continue their journey together.

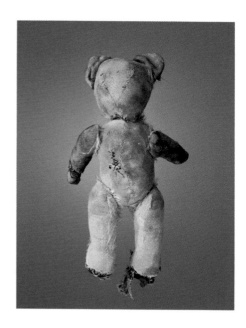

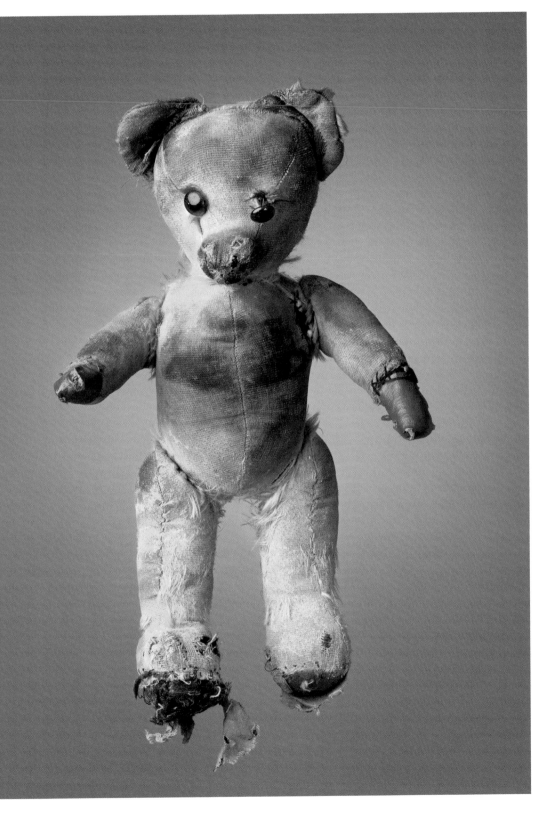

Samuel

AGE: UNKNOWN

HEIGHT: 12"

BELONGS TO: MARIA HURLEY

Samuel's age is uncertain. About five years ago I bid on him during an online auction in aid of Animals Asia, a charity I support that rescues real bears from vile farms in China and Vietnam. During the auction, usually the collectible/valuable bears go first. There were no bids on Samuel, and I thought he looked very sad, so I bid thirty-five euros for him and won. He looks like he has been well loved.

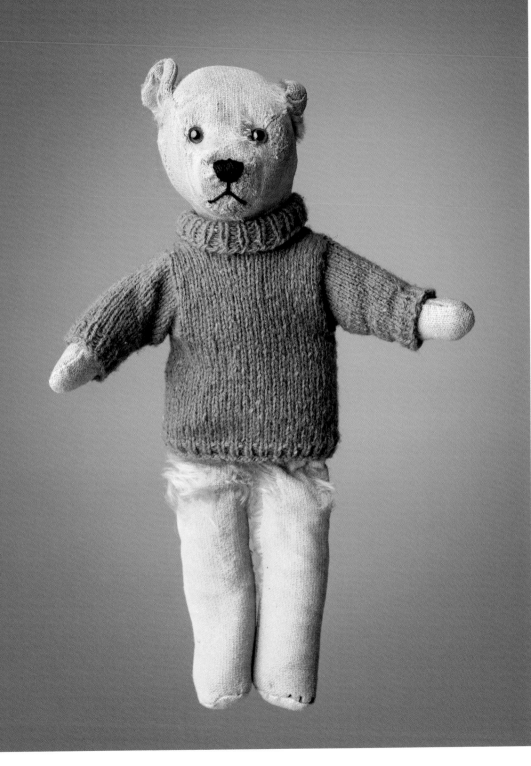

Pedro

AGE: 47

HEIGHT: 9"

BELONGS TO: MARIA HURLEY

I have had Pedro (formerly Pat) since I was a
baby. I don't ever remember not having him.
He has lost his fur and my mum has made
him some clothes. He has been a patient in
the Dolls Hospital & Teddy Bear Clinic and
has had a new nose, eyes, and hips.

 He is doing great for a senior guy, and
adores Giovanni (see p. 58). Both of these
guys have lived in many places and traveled
lots with me.

 I am currently in New Zealand working.
They are not with me this time, as it is too
far and I didn't want them in the hold of the
plane or at risk of getting lost. They are
staying with my good friend Carol, who has
her own collection of teddies, for company.

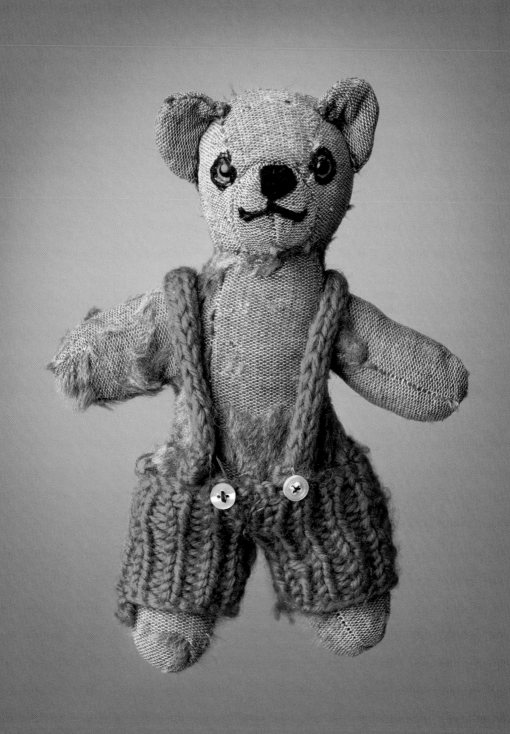

Giovanni

AGE: 40

HEIGHT: 17"

BELONGS TO: MARIA HURLEY

I knitted Giovanni (formally Joe) in primary
school when I was about eight years old.
When Joe was completed, he had a
misshapen head and a too-large nose, and
I didn't like him very much.

Many years later when I was in medical
school, I took pity on him and performed
some cosmetic surgery, giving him a new
nose and a better head. My mum made him
some new clothes (as he had been attacked
by a moth).

To celebrate his new look, I gave him
his new name, Giovanni. He is best friends
with Pedro.

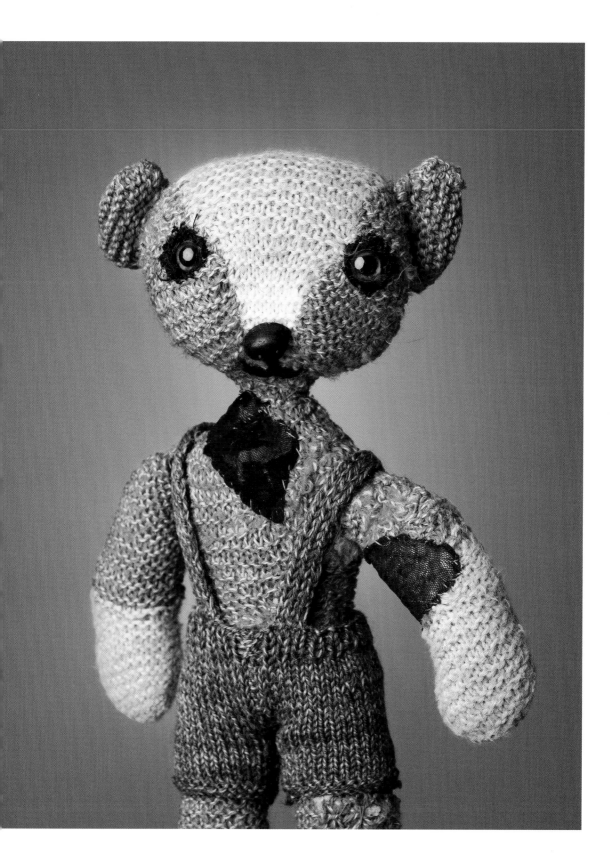

Slim Jim

AGE: 20

HEIGHT: 14"

BELONGS TO: MARIA HURLEY

I was shopping for a gift for a friend's child,
and I found Slim Jim at the bottom of a
bargain bucket in a toy-shop clearance
sale. He stole my heart. He had a tag that
read, "I am slim bear" and some instructions
for care. He reminds me of Chewbacca
from *Star Wars*. I adapted his tag to name
him Slim Jim, and I think he has quite a
few stories to tell. He currently resides in
New Zealand!

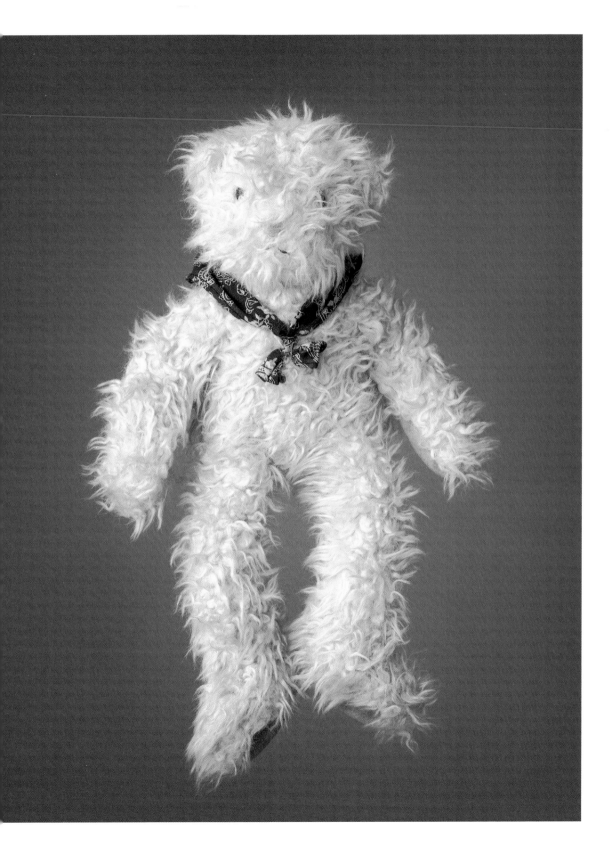

Edward

AGE: 104

HEIGHT: 23"

BELONGS TO: MELISSA NOLAN OF THE DOLLS HOSPITAL & TEDDY BEAR CLINIC

A lady telephoned me at the Dolls Hospital and said she had a dilemma.

She explained she possessed a very old teddy bear, which had belonged to her father in the early 1900s, that she loved dearly. But she was getting old herself and could see trouble ahead. It was of grave concern to her that her two sons might fall out over this teddy bear. Both had played with Edward as children and both wanted him. I told her to bring the bear in to me and we could have a chat. I identified the style and age of the bear—he was a Steiff bear from 1909—and this fact was going to play a part in the brothers falling out, because of his perceived value.

I suggested that she sell Edward to me and buy two replica bears for her sons. She was delighted with the idea and later told me she had contemplated burning Edward, such was her concern about the trouble he could cause. A happy ending all 'round; Edward is now the oldest resident of The Dolls Hospital.

The Dolls Hospital has been a Dublin institution for more than seventy years. Thousands of much-loved dolls and teddy bears have passed through its doors in varying degrees of disrepair and are returned to their owners as good as new after a short stay in the emergency ward. The Dolls Hospital & Teddy Bear Clinic is located in Powerscourt Townhouse Centre, South William Street, Dublin 2.

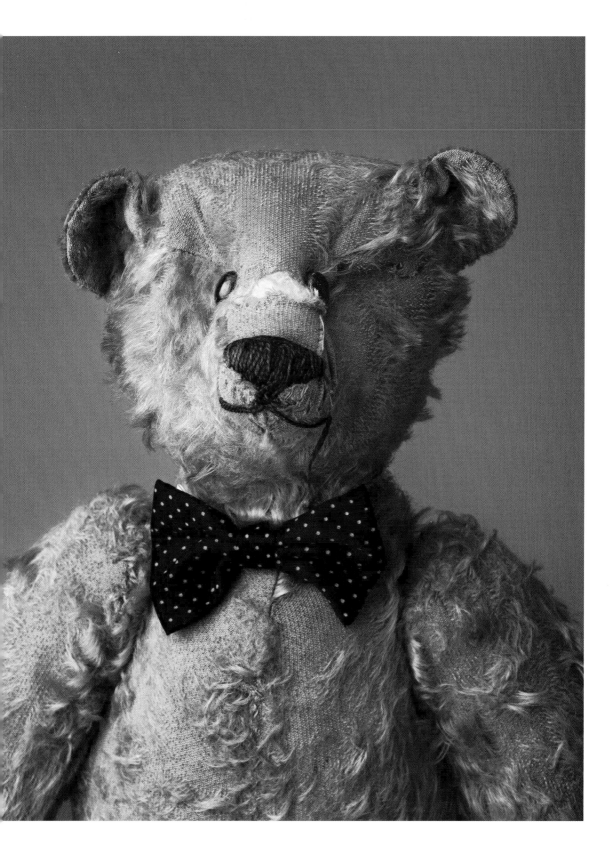

Teddy

AGE: UNKNOWN

HEIGHT: 10"

BELONGS TO: MIRIAM O'CALLAGHAN

Miriam wrote: His name is Teddy—very original, I know.

No idea where he came from. All I know is he's been here for years and all the children plus myself love him. My five-year-old, Jamie, is convinced Teddy comes out to play at night, like the toys in *Toy Story*.

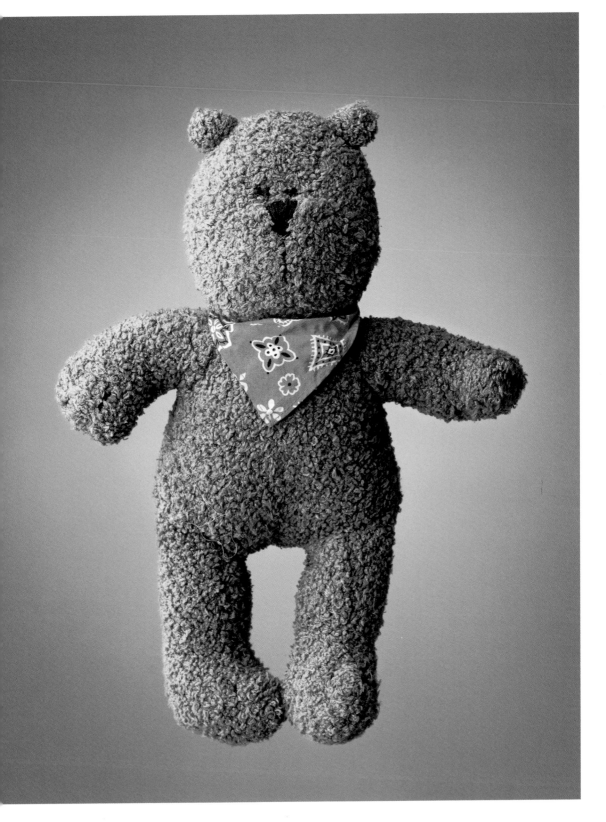

Teddy Tingley

AGE: 45

HEIGHT: 5"

BELONGS TO: NICKY GRIFFIN

Teddy Tingley belonged to my oldest brother, who gave him to me the day I was born.

I remember when I was three years old and we were heading off on holiday by train. I had just settled down in the carriage with my brothers for the journey and as the train started moving, I glanced out the window to see, to my horror, Teddy sitting on a bundle of my comics left on the station platform. Thanks to my mum roaring like a madwoman out the window, "The teddy! The teddy! I just want the teddy!" some kind person picked up Teddy and ran with him as the train picked up speed, reaching up to the window just in time for Mum to grab him. She then had to sit down and face the other passengers for the rest of the journey, marked as the mad teddy bear woman. To hell with them and the comics; Teddy was what mattered.

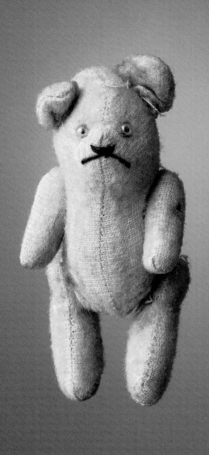

Bugs

AGE: 46

HEIGHT: 9"

BELONGS TO: CONOR OWENS/SARAH OWENS

Bugs belonged to my younger brother Conor. I think Bugs had ears, but after much hugging and childhood secret tales, they are now long gone. Two decades ago, the sea tragically took Conor from us, just weeks after the passing of our father, Peter.

Years later, on a subsequent house move, my best friend, Isobel, suggested having supper before unpacking the car, which was filled with our much-loved keepsakes, including Bugs. We returned to find everything stolen; many tears followed. Isobel suggested that I call friend and broadcaster Gerry Ryan to make a radio appeal, but I thought he would consider me a lunatic: an adult looking for her missing teddy?

It's ironic and funny to find the teddies of both Gerry and Isobel in the *Much Loved* project; they were both super free spirits, also taken too soon. Lesson: You are never too old to love your teddy bear, and there will be secret owners who will always understand a teddy loss . . .

Several years later, in a twist of fate, Bugs was found among the opened contents of a lonely shoe box and filled a room and a heart with many joyful tears for a brother's love and endearing quirkiness. Bugs has since lived in my bedroom window, marveling over nature and life, lost in thought on how to make the world a better, funnier, more creative, more equal, and kinder place . . . just as Conor and our father, Peter, did.

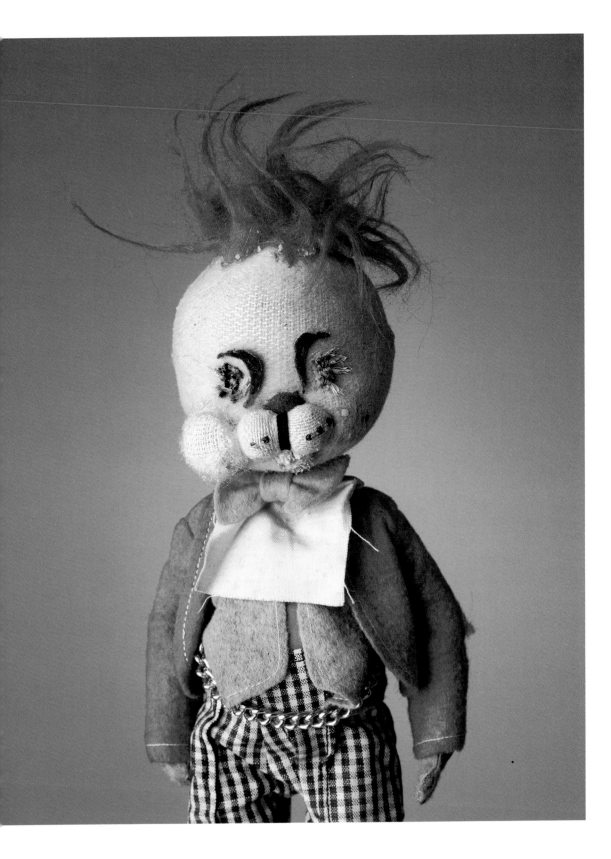

Danny

AGE: 29

HEIGHT: 14"

BELONGS TO: NUALA MORIARTY

Danny is twenty-nine years old. He was named after my friend's dad—not sure why really.

I used to pretend my bedroom was a teddy orphanage. Danny was one of my first and most cherished residents. He assumed the role of big brother to the other teddies. He and all of the other teddies used to come with me on camping holidays to France, and they took up quite a bit of the backseat, much to my brothers' disgust! But the bears loved the sea air.

Danny will always live in my bedroom, apart from when we're on the odd camping holiday.

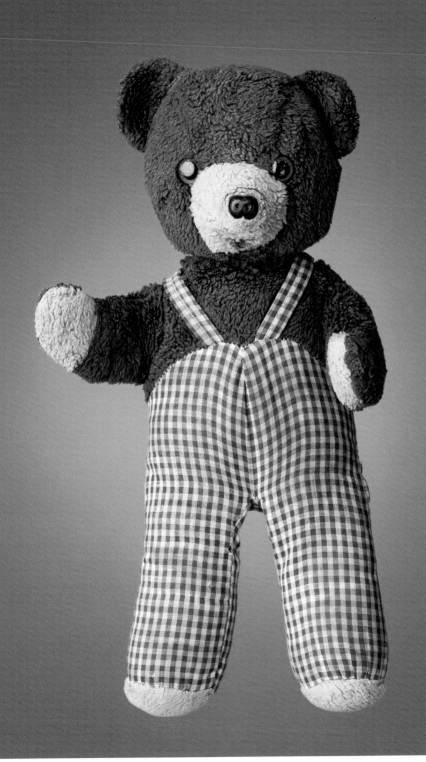

Red Ted

AGE: 34

HEIGHT: 22"

BELONGS TO: NIAMH DONOVAN MCGREEVY

Affectionately called Teddy, The Red Boy, or The Fabric Buck by my husband, Red Ted was given to me on my first Christmas by my beloved grandmother, who recently passed away. He was an instant hit and we became very attached, so much so that I used to cry myself to sleep at night at the thought of ever losing him, and on the rare occasions when my mother put him in the washing machine and on the radiator to dry, I couldn't sleep at all.

We were inseparable, and he accompanied me to the hospital and on my many travels. In America, at the age of nine, I held on to him for dear life, terrified that he might be lost, never to be found again. I hugged him so much that his fur wore away and my mother had to knit him a new skin—three times! The last time, she left his ears, nose, and paws exposed to show off a little more of the original Red Ted.

I used to dress him in my old baby clothes, but at some point he took to wearing old pillowcases and continues to do so to this day. Red Ted sleeps with me and my very tolerant husband, and I wouldn't part with him for the world.

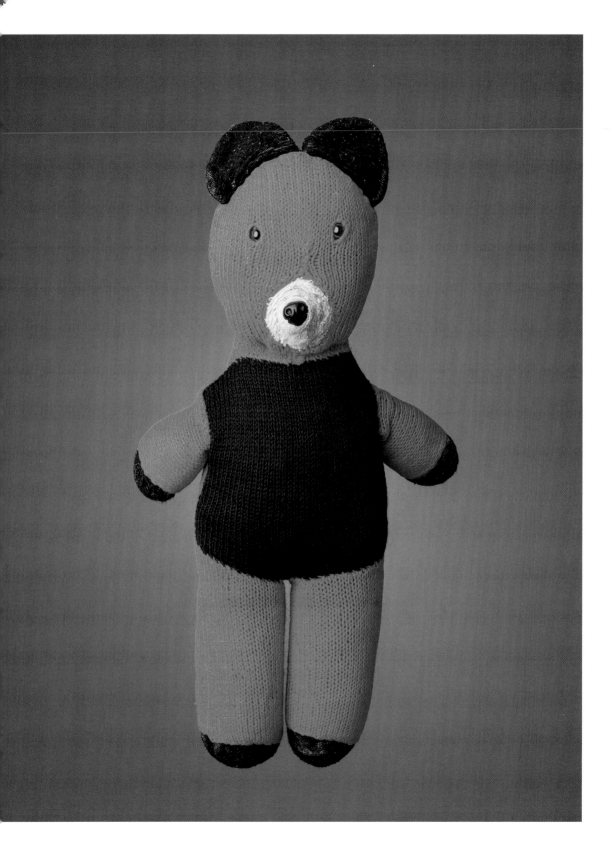

Teddy Boo

AGE: 46

HEIGHT: 16"

BELONGS TO: PAMELA FITZMAURICE

I received Teddy Boo from my grandfather for my first Christmas, when I was a month old. He has been present in my life through all the ups and downs and takes pride of place on a large, comfortable pillow on my bed.

I have to admit I have had conversations with him. I regard him as a dear friend.

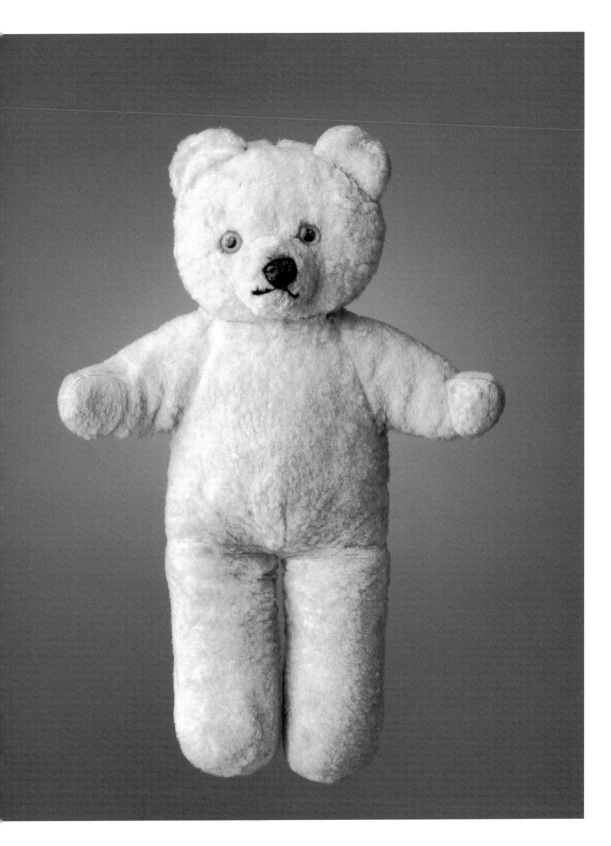

Teddy

AGE: 61

HEIGHT: 14"

BELONGS TO: GILL HALL

Teddy is as old as I am, sixty-one, and was sent to me by my grandparents when I was born. We lived in Africa and each of us got a teddy that way, so I remember the other, fortunately all-different teddies arriving in parcels for my younger siblings. I don't remember mine arriving; he has always just been there, and he has always been a "he." Are there many girl teddies? My own children had loads more than one teddy, but there was one definite main bear, and if that one went missing, it was a disaster to misplace him.

After sharing every day of my youth with Teddy sitting on the pillow, I put him in a tea chest of stuff that was stored at my parents' house, and then I went off into the wide world. The tea chest emerged years later when my parents were moving. Everything else in the chest was rubbish, but you can't throw out a teddy bear, not if it's yours; so now he lives with me again.

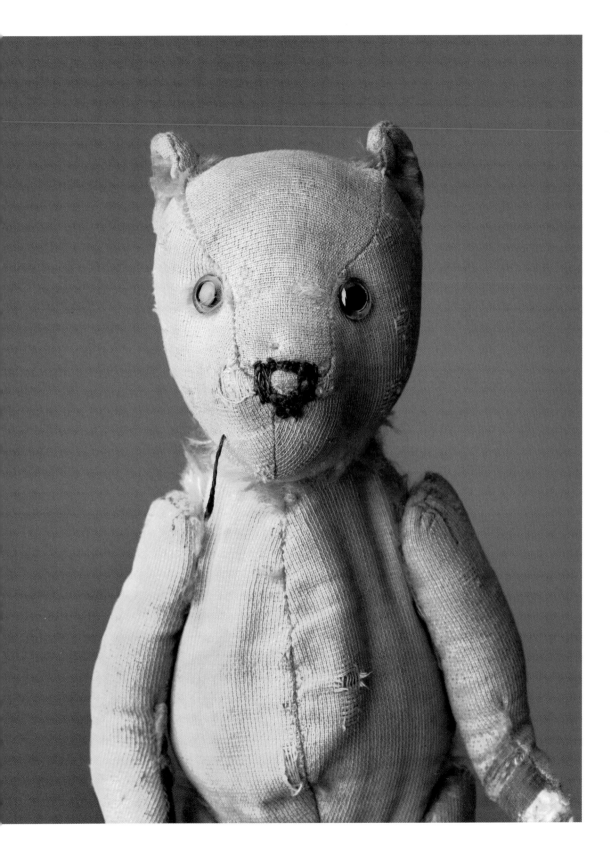

Philip

AGE: 34

HEIGHT: 14"

BELONGS TO: SARAH DUFFY

Philip is a Brown Thomas (an upmarket department store in Dublin) bear. He arrived in a navy box with a royal blue satin lining and is very posh.

He is named after a prominent obstetrician who is a friend of my mam's.

He went to the University of Wales and has been to summer camp in America, where he was kidnapped and had an adventure as a pirate. He turned up wearing a bandana and carrying a sword and map.

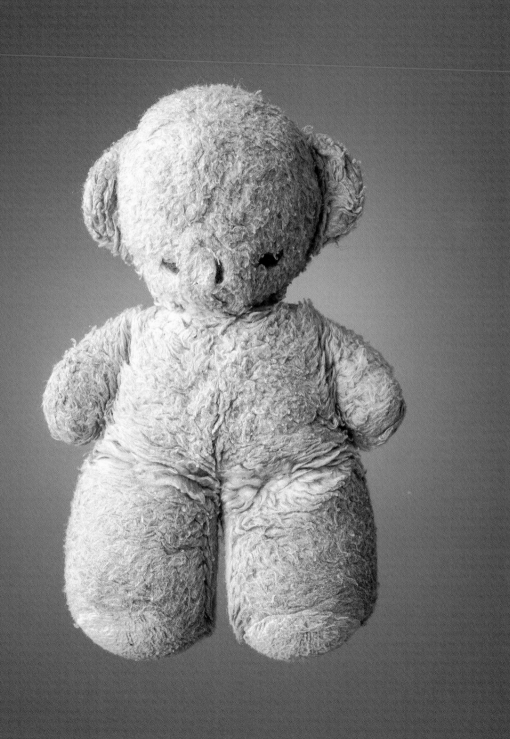

Teddy

AGE: 22+

HEIGHT: 18"

BELONGS TO: ROWAN ATKINSON/TIGER ASPECT PRODUCTIONS

This bear is from the TV show *Mr. Bean*. Over the years, Teddy has undergone several changes. When he debuted on "The Trouble with Mr. Bean," he had a smaller head. Two episodes later, his head reached its current size, but his eyes were not present until Mr. Bean placed gold thumbtacks on his face. His "eyes" have since been replaced with two small, white buttons, giving him a distinct image.

Mr. Bean behaves as if Teddy were real, buying him Christmas presents and trying not to wake him in the mornings. Teddy is often privy to Mr. Bean's various schemes and doubles as a dishcloth or paintbrush in an emergency. He has been decapitated ("Mr. Bean in Room 426") and shrunk in the wash ("Tee Off, Mr. Bean"). Teddy is also Mr. Bean's "pet" in "Hair by Mr. Bean of London," where he was used to win a pet show.

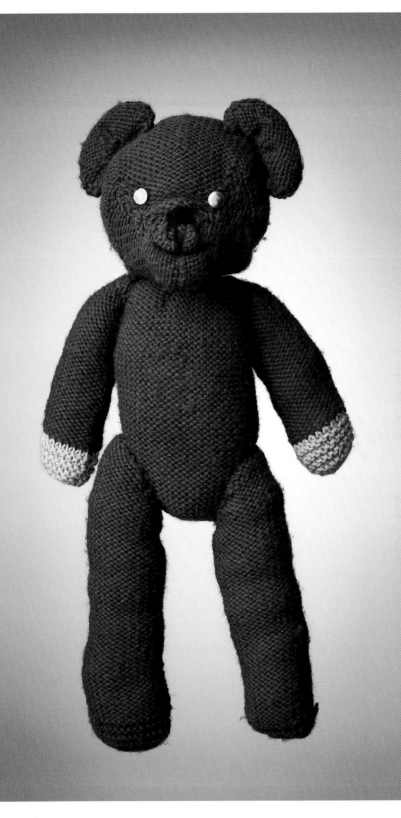

Bobo

AGE: 34

HEIGHT: 12"

BELONGS TO: SHANE MAHER

Shane sent Bobo by regular post to be photographed after hearing about the *Much Loved* project on the radio.

Shane was six weeks old when Santa brought Bobo, but now Bobo sleeps with Shane's nine-year-old daughter. Bobo was accompanied by a letter that expressed the hope that Bobo would be photogenic and asked us to take care of him.

We sent him back, registered.

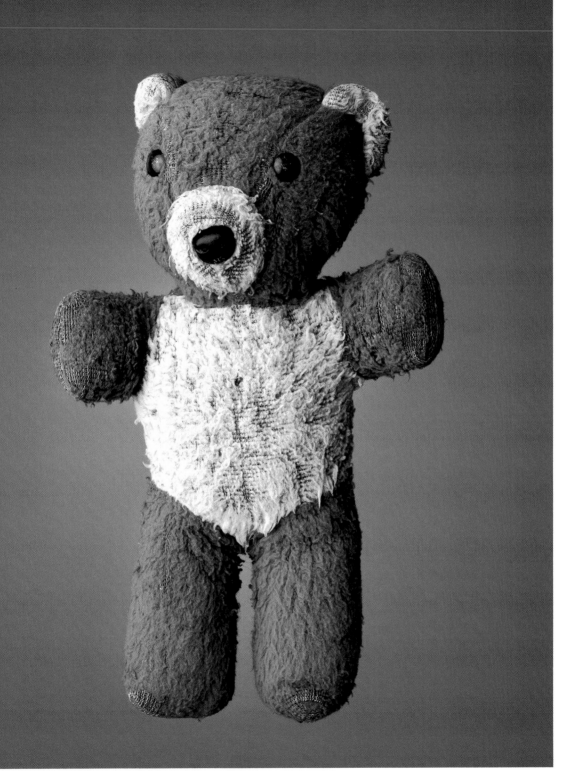

Checky

AGE: 32

HEIGHT: 14"

BELONGS TO: SARAH DUFFY

Checky's body is covered by a one-piece
teddy suit. He spent his youth half-naked.
Now that he is old and sensible, he wears
his suit to stop himself from falling apart.
He currently sleeps with Sarah's daughter
Olivia.

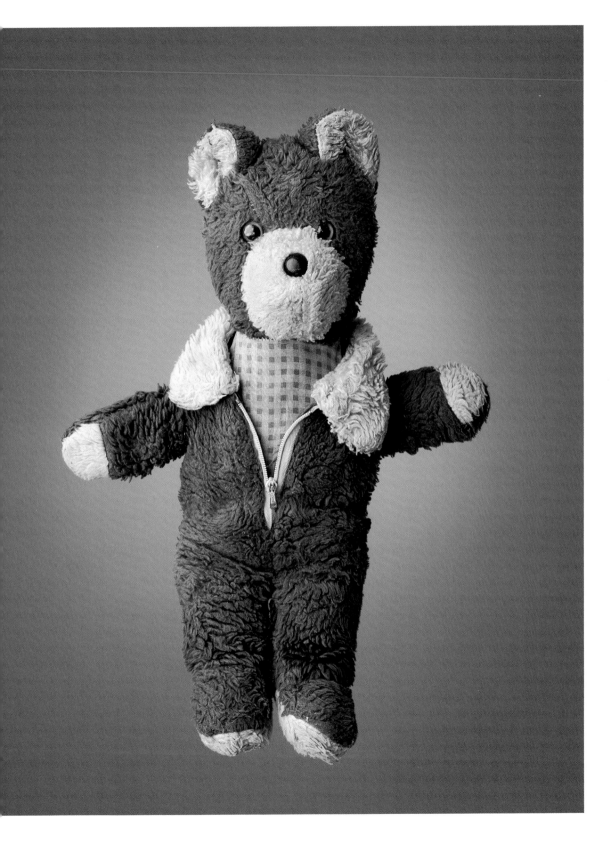

Teddy

AGE: 40+

HEIGHT: 14"

BELONGS TO: SUZANNE KEANEY

Teddy was given to Suzanne when she was a small child. The family dog became very jealous of all the attention Suzanne was giving to Teddy and attacked him, very nearly ripping Teddy's head off.

He still bears the scars from this encounter, but he usually wears a yellow silk scarf to hide them.

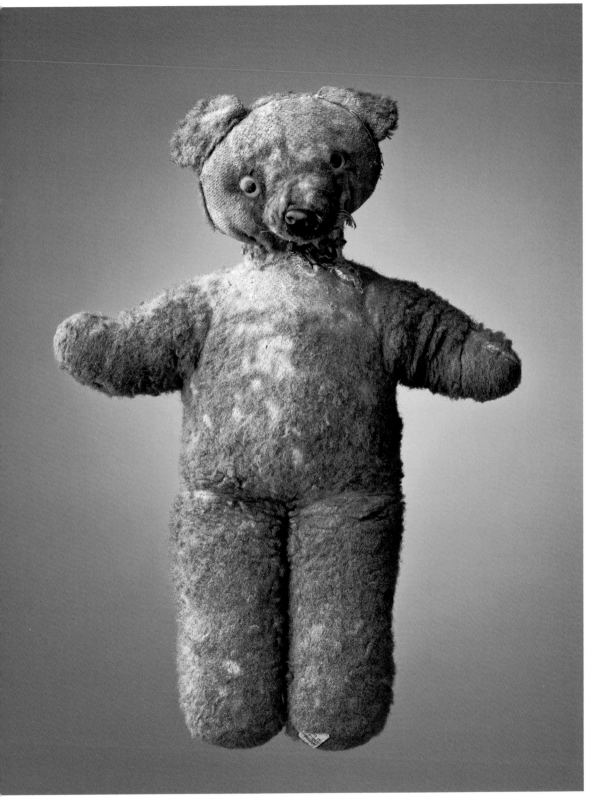

Teddy Gilligan

AGE: 24

HEIGHT: 11½"

BELONGS TO: SEAN GILLIGAN

Teddy was sent to Sean from Canada by his aunt Pat when he was born. The most important thing about Teddy is his label. Sean loved the texture of it and used it as a comforter. His mam, Mary, had to find replacement labels when they would wear out.

Teddy went on holidays with the family to Sicily and County Clare in Ireland. He also went on hospital trips with Sean and even had his teeth out at the same time as Sean. Teddy has a scorch mark on his back. Mary used to put Teddy by the fire to dry him and warm him for Sean before bed. One night he got too close.

Teddy was as important to Sean as his mam up until the age of seven. Then he was packed away for safekeeping. He was brought back to life again when he was taken out ten years later, when Sean's niece Shona was born.

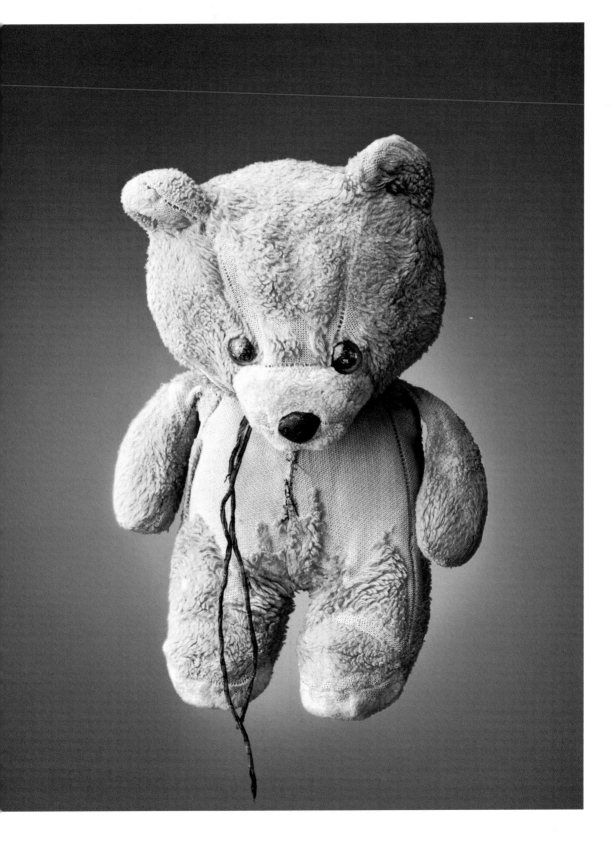

Spotty

AGE: 26

HEIGHT: 14"

BELONGS TO: SIOBHAN NEVILLE

Spotty arrived on the scene when I was just eleven days old, when Santa left him under the tree for my very first Christmas. The snowy white bear was immediately christened "Spotty" by my siblings.

In his lifetime, Spotty has traveled the world, experienced countless adventures, and done it all in style. Sporting a fabulous wardrobe of bow ties, cardigans, and vests— all handmade by Mammy Neville!

He's also been a loyal friend—his lips of thread have kept many secrets and his fluffy paws have dried countless tears. Twenty-six years on and we are as close as ever, although perhaps both a little worse for wear!

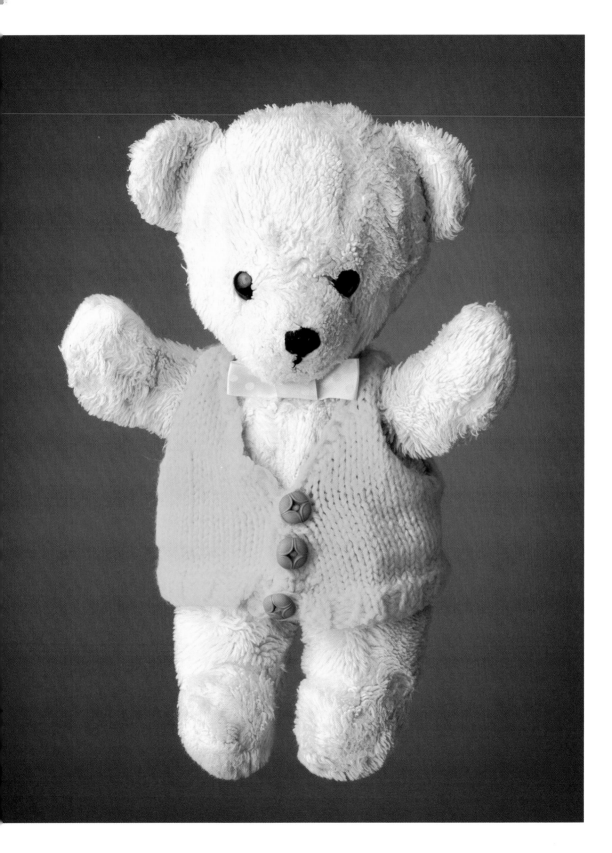

Teddy

AGE: 40+

HEIGHT: 14"

BELONGS TO: SUZANNE KEANEY

Originally Teddy had yellow fur and pink hands.

He was left behind on a trip and successfully made it home through the postal service.

Suzanne says if the house was burning down, Teddy is the one thing she'd rescue.

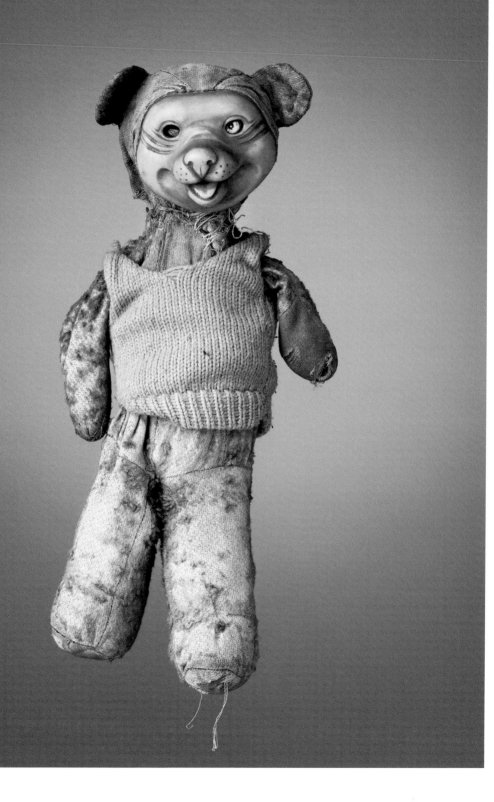

Teddy Bear

AGE: 15

HEIGHT: 7"

BELONGS TO: DAWN LOWE

I would like to call your attention to heroic
Teddy Bear, who comforted my late
husband, Steve Goto. Steve had suffered
a ruptured brain aneurysm and subsequent
stroke. During his time in the hospital,
Steve hugged this bear so fiercely that
no one could take it away from him. This
bear spent long nights in the hospital with
Steve when I couldn't be there. Steve died
April 20, 2002, but the bear remains
with me.

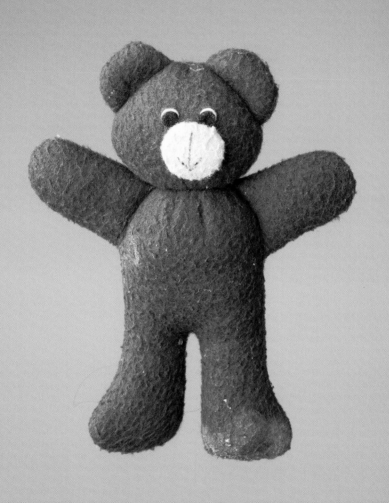

The Ted Family

AGE: EARLY 30s

HEIGHTS: 8½", 9", AND 6½"

BELONGS TO: SIOBHAN RYAN

The Ted Family was purchased from the old post office shop in Templeogue (Dublin). Not very expensive bears, I'm told, but worth their weight in gold, for they truly were my constant companions.

In their prime, their little torsos were cloaked in bright blue gingham cloth. Now visibly threadbare, they are pieced together with old bandages and fabric swatches!

These days they no longer follow me everywhere, but instead have pride of place in the pink bedroom, back home in their original den.

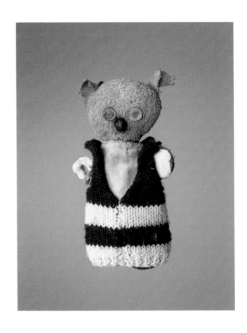

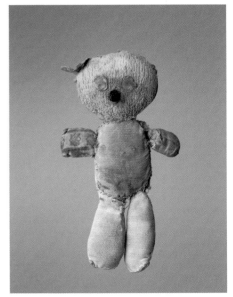

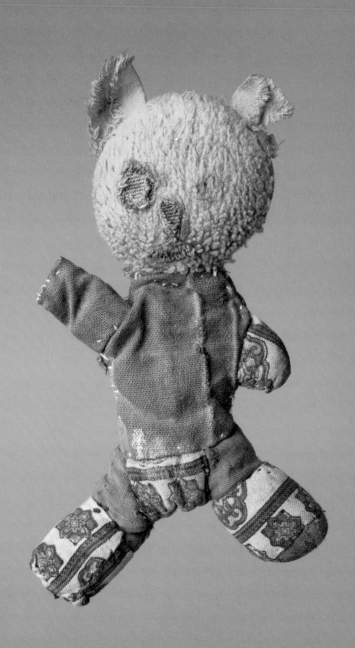

George

AGE: 44

HEIGHT: 17"

BELONGS TO: AUDREY MCDONALD

Around 1969 or 1970, I was due a bicycle from Santa, but he gave me a teddy instead, leaving me a note that my bike wouldn't fit down the chimney. I was thrilled with my teddy, though. He had bright orange hair, huge eyes, a black tongue sticking out, and a long tail. And he had a compartment I could put my nightdress into.

George has now traveled the world with me (including Asia, the USA, and Europe) and comes on all our family holidays. Thankfully, my husband is also very fond of George, because the teddy sleeps in our bed each night. My children treat George as just another member of the family who has always been around.

Every couple of years, my mum takes George off to Kilkenny for vital repairs. She washes and dries him (he takes a long time to dry due to his big head!) and then she patches and repairs him. I miss him every night he is away from me and love when we are reunited.

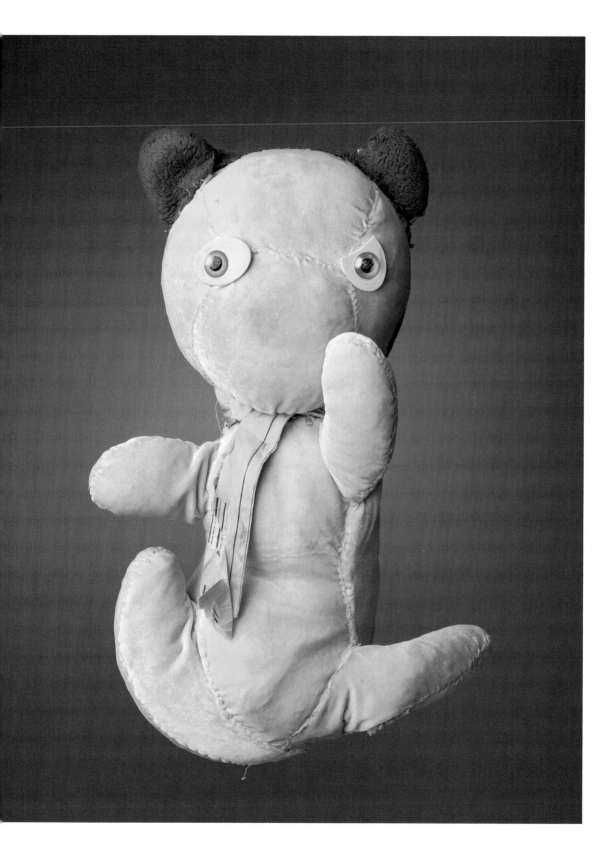

Ted

AGE: 43

HEIGHT: 15"

BELONGS TO: TOM O'CONNOR SR.

Sinead Keogh wrote: Ted was handmade for my husband, Tom, when he was born. My mother-in-law sent Ted up from the family home when we got married in 2005. Our baby, Tom, was born the following year, and on his first night home from the hospital, I was shocked to find my husband had placed this manky Ted in the basket beside my pristine newborn! I banished Ted to a shelf in the bedroom, where he now happily stays.

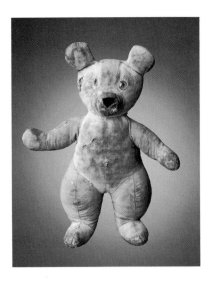

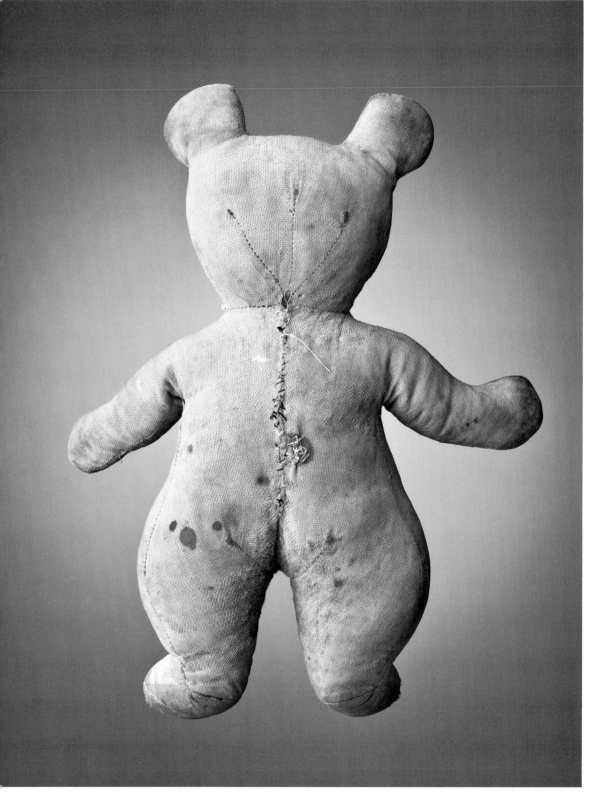

Beary

AGE: 6

HEIGHT: 12"

BELONGS TO: TOM O'CONNOR JR.

Sinead Keogh wrote: Tom turned six in September. When he was born, he got the teddy as a gift from a friend of mine. Tom calls the teddy Beary, and he goes everywhere with him. I always know when Tom is tired—I hear him running upstairs to get Beary off his bed for a cuddle.

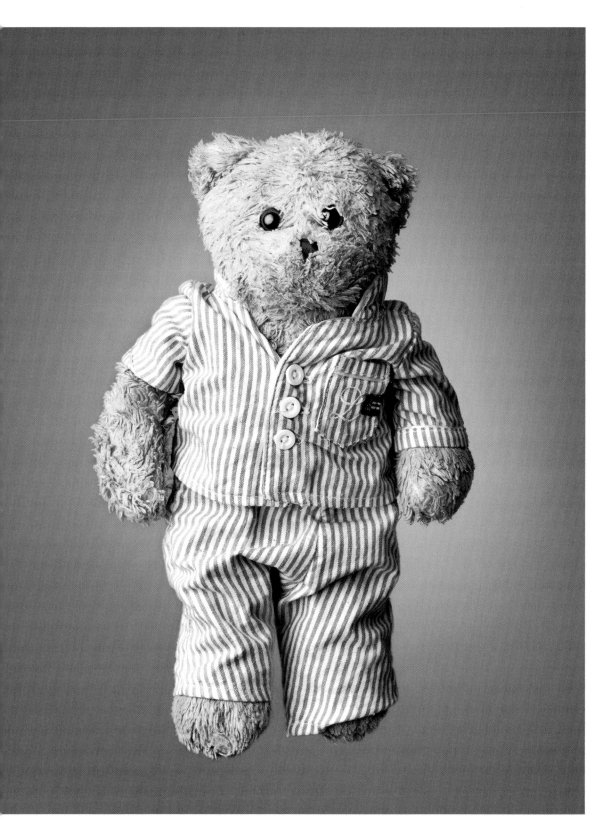

Patsy

AGE: 7

HEIGHT: 8"

BELONGS TO: TOM MCLOUGHLIN

Patsy belongs to Tom's son, also Tom, who has had him all his life. He has been stitched back together countless times.

One day, Tom Sr. had to leave early from a family holiday in Waterford. On arriving back in Dublin, he received a phone call asking if he had Patsy. Sure enough, there was Patsy sitting in the back seat. Tom had to turn 'round and drive two hours all the way back to Waterford so his son wouldn't miss his teddy.

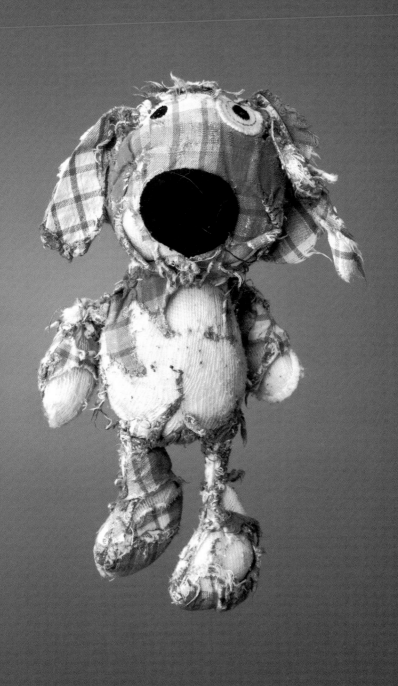

Bookie

AGE: 24

HEIGHT: 12"

BELONGS TO: LAUREN DE LA ROSA

I received Bookie from my mama and papa when I was three months old. I would suck my thumb and rub Bookie's right ear, which now looks like a long plait. We were inseparable until I left for college.

Once, we lost Bookie. With me in a stroller, my mama retraced our steps around town. We found Bookie on a lower shelf at the store where we had gone to find some new fabric for Bookie's nose.

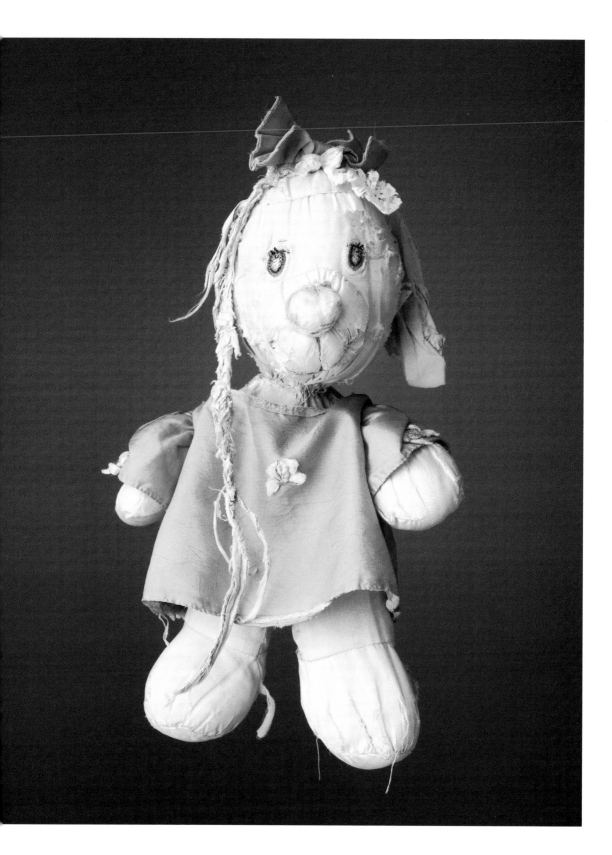

Floppy

AGE: 6

HEIGHT: 9"

BELONGS TO: EVE MCLOUGHLIN

Floppy has gone everywhere with Eve from the time she was able to hold him. She rubs his paw on her nose and lips as she sucks her thumb. He makes her feel safe and sleepy.

One day in the park after Eve fell asleep, Floppy fell out of the buggy without anyone noticing. My husband, Michael, was beside himself that night because Eve was so upset when she found out the bad news. He got up at some unearthly hour and was standing at the gates of the park when it opened at 7:00 am. He searched everywhere and in desperation tried all the garbage bins. He lucked out. He says that finding Floppy in that bin, apart from his wedding day and the births of the kids, was the happiest moment of his life.

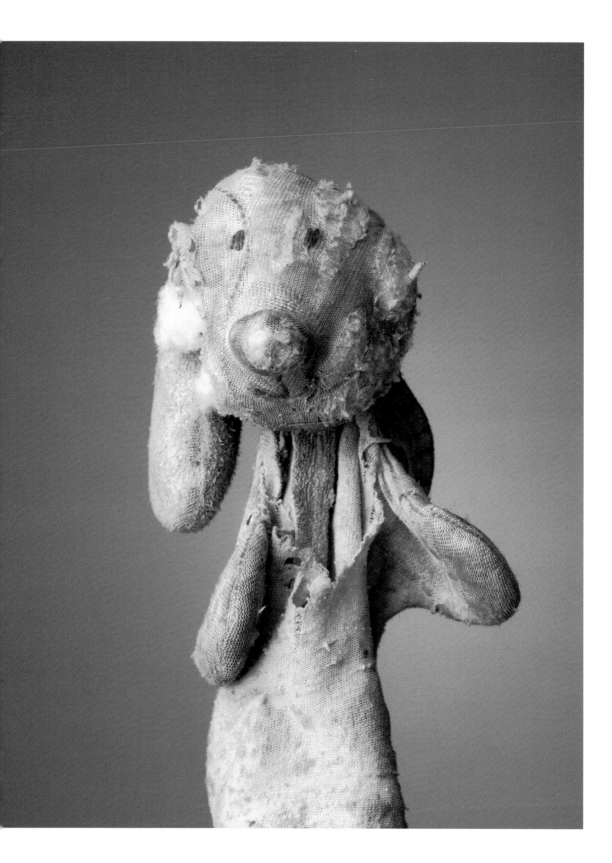

Daddy Bunny

AGE: 8

HEIGHT: 14"

BELONGS TO: ZOE BRACKEN

Zoe has three teddies: Mummy Bunny,
Daddy Bunny, and Nanny Bunny. They
all have to go on holiday and travel in their
own suitcase.

 Zoe has to sleep on the edge of her
bed, because the three of them need
their space.

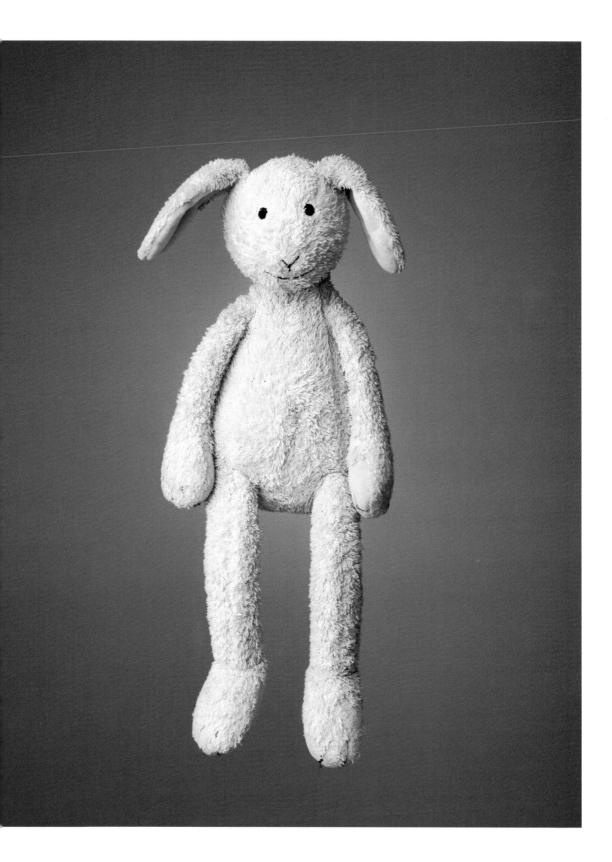

Teddy

AGE: 17

HEIGHT: 10"

BELONGS TO: YIANNIS GOUMAS

Teddy and I used to go everywhere together. He was always tucked in under my chin.

I remember this one time when we went to the Acropolis in Greece and they wouldn't let me in because they thought Teddy was a bomb! They tried to take him off me, but I wouldn't let them, and my parents convinced security that he was just a teddy.

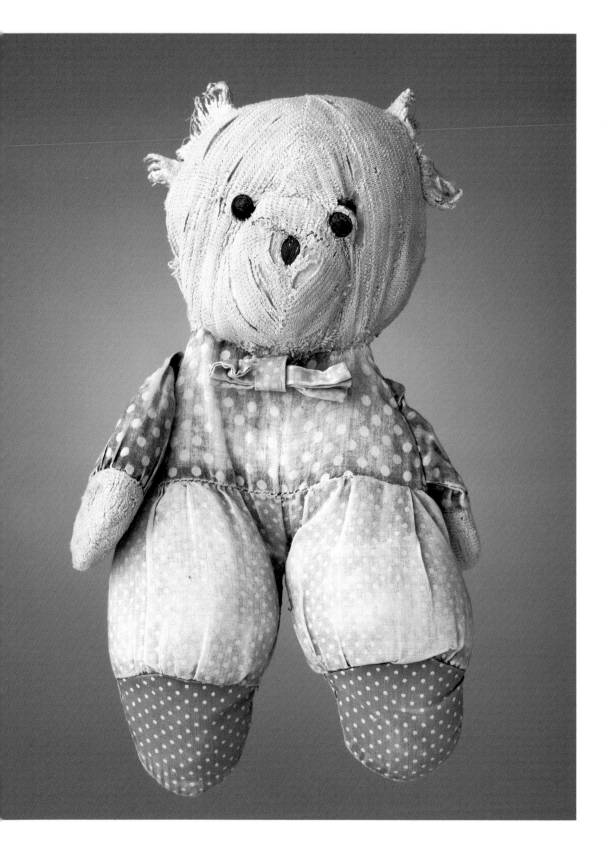

Bear

AGE: 44

HEIGHT: 11½"

BELONGS TO: DAVID CASHION

When I was about four, Bear went missing. My grandmother had given him to me not long after I was born, so he and I were pretty close and his disappearance was devastating. Inconsolable months went by, and around this time we started packing up our house to move to a new city. Bear was discovered stuffed into a corner of the couch under the cushions (I suspect on purpose by my brother). During his absence, I had maintained a very idealized vision of him, and this threadbare, nose-less, floppy creature was not it. I was devastated again. In a short while, though, I looked past his physical flaws and we were in love for many more years.

Bear's sartorial style didn't come about until a long time later when I found my equally old baby blanket. That, too, had suffered much loving abuse and I decided to just poke Bear's arms through a couple of holes in the disintegrating fabric and call it a vest. They look good together.

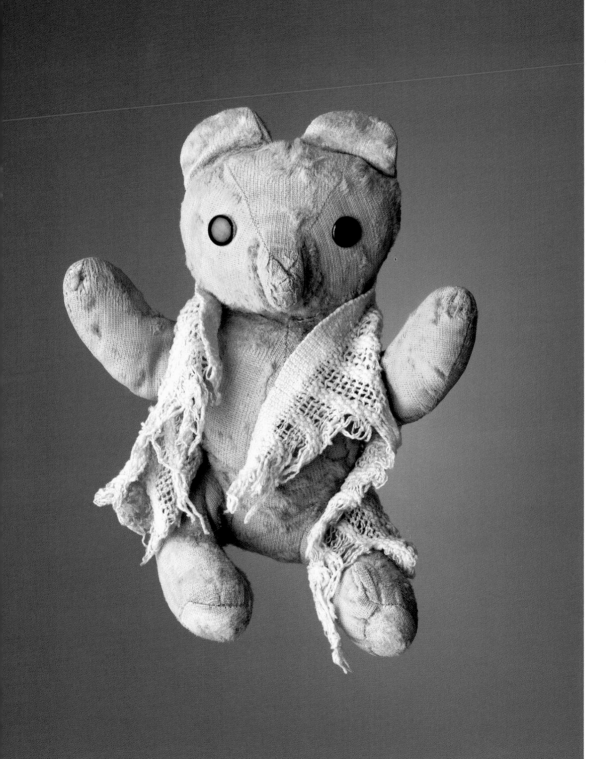

Teddy

AGE: 60+

HEIGHT: 18"

BELONGS TO: DAVID DAVIN-POWER

Known simply as "Teddy," he was born in the early 1950s, exact date unknown, and he has lived in Dublin since then. He suffered an early trauma when one of his owner's friends accidentally stabbed him with a screwdriver, depriving him of his voice for twenty years. In 2001, he underwent a life-changing operation that restored his growl and replaced an eye he had lost. Since then he has lived in comfort and contentment with his owner and friend of nearly half a century.

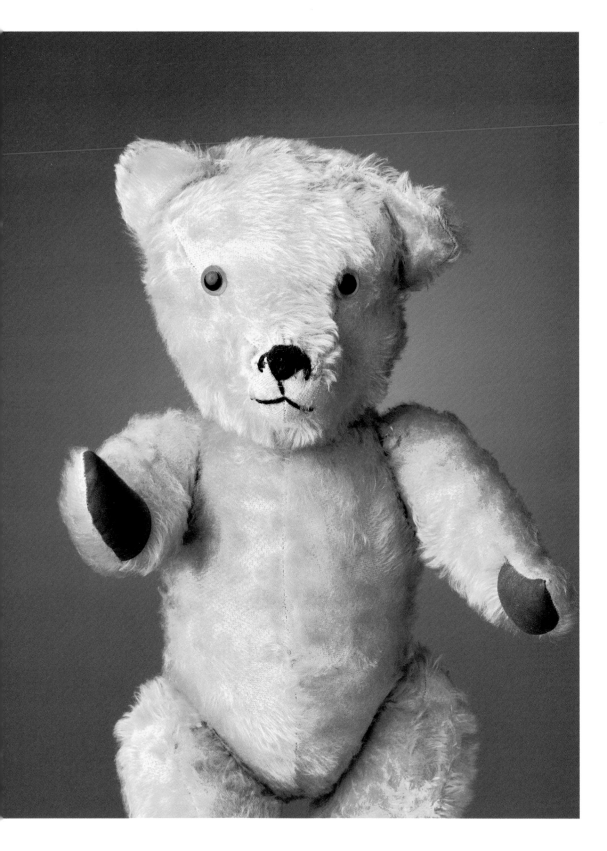

Bunny and Rabby

AGE: 36 AND 29, RESPECTIVELY

HEIGHT: 16"

BELONGS TO: SINEAD GIBNEY

Rabby is about twenty-nine years old.

Before Rabby there was Bunny. Bunny was given to me the day I was born by my mum's friend Jennifer. When I was seven years old we moved back to Ireland. She couldn't believe that I still slept with Bunny every night, so she gave me Rabby, a fresh copy.

Obviously, I had no time for this impostor. I tried to rough him up a bit to make him more like Bunny, but he was too white and too full of stuffing, so he went in a drawer. Then, when I was twenty-one, I lost Bunny—a dark time for me. But luckily, Rabby was able to step in and before long was as beat-up as Bunny ever was.

I have received a lot of stick over the years for Rabby and for Bunny before him. So it's really great to see other teddies in such states of disrepair.

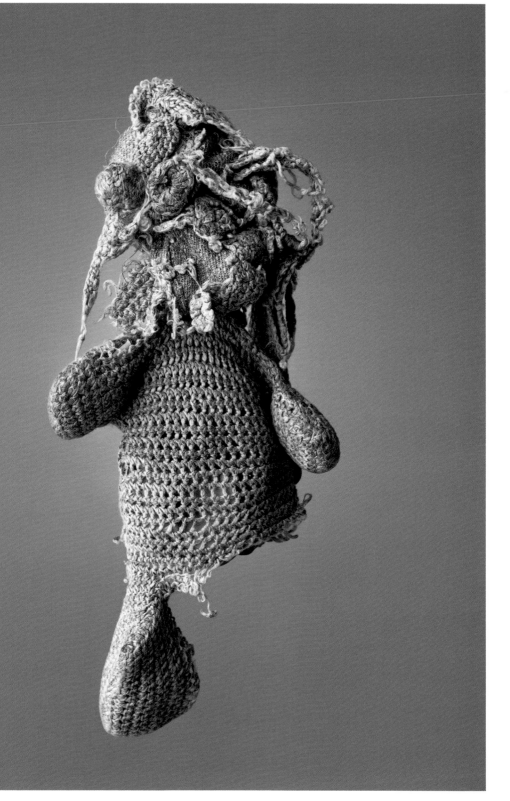

Mr. Ted / Johnny's Bear

AGE: 43

HEIGHT: 29"

BELONGS TO: YVONNE GIBSON

Yvonne wrote: Mr. Ted was bought forty-three years ago for my oldest brother Johnny, who was born in January 1970 with Down syndrome and holes in his heart. According to my mum, Johnny was besotted with Mr. Ted from the moment he met him and the two became inseparable. Unfortunately, Mr. Ted only got to bring joy to Johnny for five years as he died in 1975, a few months before his sixth birthday and three years before I was born.

After Johnny's death my mum could not part with Mr. Ted, and he has been known in our house as "Johnny's bear." As children we all played with Mr. Ted, and he did not have an easy life with three of us to contend with, but he has miraculously survived. His coat is pretty bare these days and he has a bit of a tear under one arm. He also has non-original eyes that are prone to falling out, but all this makes him who he is and tells the story of the role he has played in my family.

A poem my mum wrote, which I think sums up his story better than I ever could:

Mr. Ted

From the toyshop window he watched them go by,
If she had some shillings she'd buy him for her boy,
A gift from an uncle the journey began,
Twelve shillings sixpence that was the price tag.
The baby's eyes danced on seeing Mr. Ted, he
 responded by tilting his head.
Hugs and cuddles and fun in the bed, always there
 was Mr. Ted.
It was sudden when the angels came calling.
Mr. Ted in the corner a tear from his eye falling.
He was wiser now but still liked fun,
With brother and sister life went on,
In no time at all they were grown up and scattered.
Into the wardrobe he was put tired and tattered.
He was rescued at last by his first owner's sister.
She brought him home to await the stork's visit,
In the corner he tilts his old head,
More confident now is a mature Mr. Ted.
—Maura Murphy Gibson

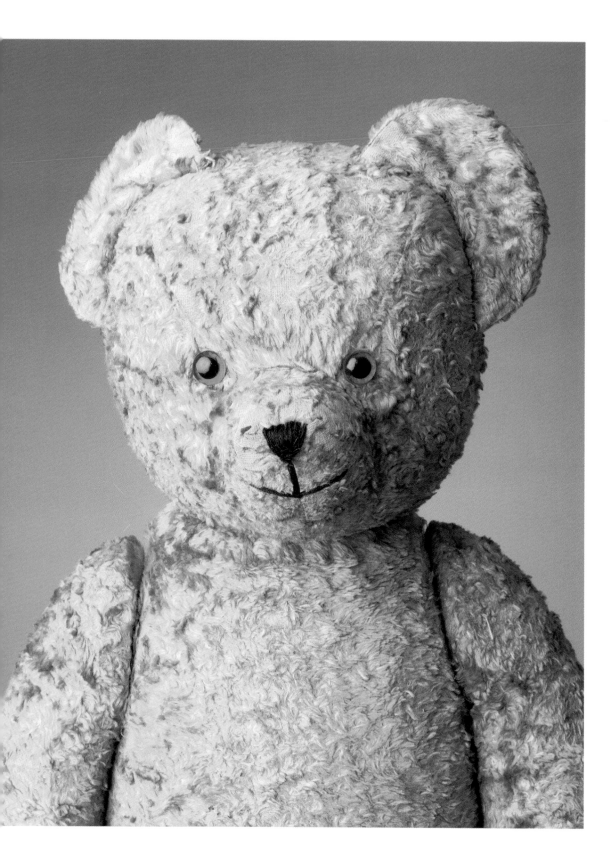

Bunny

AGE: 9

HEIGHT: 9"

BELONGS TO: BEN BRACKEN

Bunny has been on every family holiday for the past nine years.

He was bought for Ben when he was born and has been his companion ever since. Ben hides Bunny when his friends come 'round, but he always appears again at bedtime.

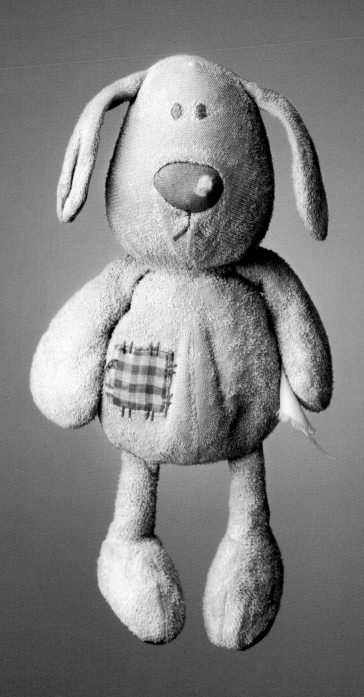

AGE:

HEIGHT:

BELONGS TO:

TAPE YOUR IMAGE HERE